"JoEllen Koerner is a courageous, loving, caring soul mate! We in nursing share so many privileged moments with patients and families. In her book, she shares some of those special times in her life. We sometimes give so much, we forget to 'fill our own buckets' and heal ourselves. Thank you, JoEllen, for encouraging all of us to get in touch with our inner-self as we heal ourselves. We will all be better human beings and nurses."

Rhonda Anderson, RN
Chief Operating Officer, Desert Samaritan Medical Center

"JoEllen provides a moving story of the pain, sorrow, joy, and challenges she has experienced over her career as a nurse, in her role as a mother and wife, and as a result of her openness to the healing of the Lakotas. The surrealistic journey she shares offers a vision of other options and ways of knowing that inspire and transform the reality some of us believe is the only way. This is a lesson for all who profess to be healers about what we bring to the multiple roles and lives we experience as healers. Her willingness to share it with us is an invaluable gift to all we aspire to do as nurses. May it inspire all of us to that same level of openness into which we will invite other experiences and ways of being and knowing."

Geraldine Bednash, Ph.D., RN, FAAN
Executive Director, American Association of Colleges of Nursing

"What a gift! This captivating and inspiring personal journey will require everyone to reflect on the real meaning and purpose of our family lives, throughout the years. The author's bravery, insights, and intuition honor all caring professions."

Carol Ann Cavouras, RN, MS
President, Labor Management Institute

"*Mother, Heal My Self* is more like a healing than a book. Rarely does a work appear with such power to transform the reader. JoEllen Koerner reminds us of the ability of human consciousness, tradition, ritual, love, compassion, and caring to make life-and-death differences in healthcare. As a picture of what a complete system of healing could be, in which ancient tradition and modern science stand side by side, there is no better example."

Barbara Dossey, RN, Ph.D., FAAN
Author, Florence Nightingale: Mystic, Visionary, Healer
Director, Holistic Nursing Consultants

"JoEllen Koerner's luminous book reminds us that there are realms of healing which modern medicine is in grave danger of forgetting. This riveting account will challenge your picture of reality and open you to new dimen-

sions of the possible. *Mother, Heal My Self* should be read by all physicians alongside *Gray's Anatomy.*"

Larry Dossey, M.D.
Author: Healing Beyond the Body
Executive Editor: Alternative Therapies in Health and Medicine

"Anyone who has pondered the mystery of life by being present at the moment of death will enjoy this powerful story of a mother and daughter's courageous journey. Like Isabel Allende's account of her daughter's critical illness in *Paula*, this story awakens in one the desire to plumb his or her own spiritual depth."

Ted Holloway, M.D.
District Director of Public Health

"The perspective that we are 'souls on an earthly journey' truly was a transformational perspective for me and one I believe would result in a health care system based upon needs of the patients rather than the providers. I thank JoEllen, a person with a history of leadership for our profession, for daring to lead us in yet a new way with a new voice and story. By this authentic and poignant personal story we her colleagues and friends have the privilege of a guided journey of personal discovery and growth."

Nancy F. Langston, Ph.D., RN, FAAN
Virginia Commonwealth University
Past President, National League of Nursing

"Through use of her incredible story, JoEllen provides a unique lens for each of us to discover new dimensions of ourselves and our work. For nurses, healthcare professionals, and leaders who find themselves at a crossroad on their journey, this book is a timely and transforming gift."

Julie MacDonald
Chief Operating Officer , St Joseph Mercy Hospital

"In a world increasingly dominated by multiple cultural traditions and attracted to alternative therapies, this book is a marker event. It offers guidance to individuals who bridge different cultures as they seek to achieve intergenerational understanding of their place in a family that spans traditions and geography. It maps out how health is shaped by the relationship between self and society. It holds the promise of enabling readers to achieve 'thanks-living.'"

Angela Barron McBride, Ph.D., RN, FAAN
Indiana University School of Nursing
Senior Vice President, Academic Affairs-Nursing
Clarian Health Partners

"This is a story that had to be told! It is a story of mothers and daughters and the anguish, yet intense loving, of families in health and illness. The everpresent compassionate wisdom of Wanigi Waci highlights the transforming

power of caring relationships. Thank you, JoEllen, for sharing your experience and the meaning it holds for us personally and professionally. It gives new expression to being present in the health care experience."

Margaret A. Newman, RN., Ph.D.
Author: Health As Expanding Consciousness

"One awakens in JoEllen's journey to the memory that nothing and no one is separate. Indeed, that the diverse and resplendent gifts of all humanity is not only complementary, but essential to the wholeness that is health. *Mother, Heal Myself* is a melody, rich with the creative and healing potential that is the essence of our shared human experience."

Tyler Norris
President, Community Initiatives

"From the first sentence, JoEllen Koerner lovingly and with great skill drew me inexorably into her life and experience and called me forward into her rich personal and spiritual journey. The depth of her personality and the warmth of her character came through her words, creating a mosaic of family, profession, person, and place. Each element of her journey contributed a thread to the tapestry of history, humanity, healing, hope, struggle, perseverance, and the ultimate triumph of love. This little book is one of the best explications of the universal mystery of wholeness, healing, and health I have read and one that will encourage and inspire anyone blessed enough to explore its pages."

Tim Porter-O'Grady, Ed.D., Ph.D., FAAN
Author: Leading the Revolution in Health Care
International Health Systems Consultant,
Associate Professor, Emory University

"This is a profoundly captivating story of physical and spiritual healing that challenges traditional Western medicinal practices. I found that once I read the first sentence, I was driven to continue to read the entire story. All health care providers and students of the health professions should read this book; their views about illness and the decisions we all make to overcome illness and heal will be forever altered. I personally want to thank JoEllen and Kristy for sharing with readers their pain, courage, and tenacious steps to understand their difficult challenge in the context of their heritage. This is a true story of love, challenge, spiritual growth, and understanding so that healing could prevail."

Marilyn Rantz, RN, Ph.D., FAAN
Sinclair School of Nursing and Family and Community Medicine
University of Missouri, Columbia

"JoEllen is a remarkable storyteller. She weaves the tapestry of her story with grace and sacred spirit. I found myself drawn into her world, her struggle, her quiet triumph, her glorious wisdom."

Pamela Austin Thompson, MSN, RN, FAAN
Chief Executive Officer, American Organization of Nurse Executives

"JoEllen Koerner weaves a magical journey that envelops the reader. It is a truly magnificent work. Gripping. Moving. A work that cannot be put down once started. And, once completed, it cannot be put out of one's mind and soul. It is a soulful gift from a great leader, healer, educator, and person."

Fred Titze, MHA, CMPE
Chief Administrative Officer, Arnett Clinic

"As I look back over my life's journey, I have become increasing grateful for the people and experiences that contribute to my continuing transformation. Knowing JoEllen and reading her new book has been one of those powerful experiences. My deepest gratitude for her important contribution to me and countless others."

Ann VanSlyck, RN, MSN, CNAA, FAAN
President and CEO, VanSlyck & Associates, Inc

"This beautifully written story is both a gift and a call to action for those who have chosen to be healers in a health care system whose relationship roots are living in a drought. The words so elegantly written connect one with the Spirit within, that does not demand a solution, but provides a wisdom on how to live within the daily polarities (unsolvable problems) that are always found in a life well lived.

Bonnie Wesorick,
Founder, CPM Resource Center

"The unusual journey between traditional healing and alternative medicine raises renewed awareness of the integrative powers of soul, mind, and physical being. This intergenerational healing journey could well be applicable worldwide as we strive to understand, accept, and encourage each person's individual life and death pathway. JoEllen's work has the effect of climbing the highest mountains in challenging peaks of our personal life's journey."

Barbara J. Brown, Ed.D., RN, FAAN, FNAP Editor
Editor, Nursing Administration Quarterly
VP/Editor, Nurse Week/Mountain West

"JoEllen Koerner is a highly gifted leader and communicator. In *Mother, Heal My Self* she tells a moving, spirited, and personal story that offers many lessons. It is a beautifully written and fascinating tale about a most significant community: the people from whence we came and with whom we live. As unique as her story is, its themes speak to universal questions about the body, mind, and spirit of health care, and this precious journey called life."

Catherine Robinson-Walker
President, The Leadership Studio®

MOTHER, HEAL MY SELF

AN INTERGENERATIONAL HEALING JOURNEY
BETWEEN TWO WORLDS

May 2003 —
For Mary —
... + our shared
journey towards
authenticity and
wholeness —
Warmest Regards
Jo Ellen

MOTHER, HEAL MY SELF

AN INTERGENERATIONAL HEALING JOURNEY
BETWEEN TWO WORLDS

by
JOELLEN KOERNER

CRESTPORT PRESS
CALIFORNIA

MOTHER, HEAL MY SELF:
An Intergenerational Healing Journey Between Two Worlds
By JoEllen Koerner

While this book captures true events of my life, I have changed some of the names, titles, locations, and dates.

Excerpt from CROW AND WEASEL by Barry Lopez. Text copyright © 1990 by Barry Holstun Lopez. Reprinted by permission of North Point Press a division of Farrar, Straus and Giroux, LLC.

*I wish to acknowledge Lyn Coffin's poem that closes this book. She penned it on the back of an envelope for me. If you haven't been introduced to her poetry, may I commend to you her books **Crystals of the Unforeseen (Austin, TX: Plain View Press, 1999), Human Trappings** (Omaha, NE: Abattoir Editions, 1980), and **The Poetry of Wickedness** (Ithaca House, 1981).*

Crestport Press
5021 Gregory Court
Santa Rosa, CA 95409

Library of Congress Control Number: 2003102097

International Standard Book Number (ISBN)
0-9725098-0-1

This book is dedicated to all the ancestors of the German-Russian Mennonites and the Great Sioux Nation who made this life story possible. It is also dedicated to all my relations currently living and yet to come. May they each find their own path to health and wholeness in a rich and meaning-full way.

Healing will happen,

Health is optional,

Wellness is the balance.

—WANIGI WACI

Table of Contents

Prologue

During my thirty-five-year nursing career, I have been privileged to sit with patients and families of patients awaiting imminent death. I have had the honor of helping families cope with difficult medical decisions. I have been present to many people in their suffering. But not one of those many encounters over the years prepared me for this horrific night, when the patient was my precious daughter and she lay before me, wishing to die.

This crisis followed a long and difficult pregnancy and weeks of incapacity from a stent placed into her left kidney to help pass several large kidney stones. She had gone into the hospital to have it removed so that she could once again enjoy limited mobility and some respite from the pain. She returned

to her room following kidney surgery in nearly unbearable agony. Rather than remove the stent, the surgeon also had to place one in the other kidney to help pass a total of five stones that no Western medical treatment or device could dissolve, and the resulting pain was beyond all pharmaceutical relief. Her breath was short and gasping, her hands clutched the sheets, and her ashen face was drenched with perspiration. It was more than I could bear to witness—and there was absolutely nothing I could do for her.

If ever I had wished for the power of the Gods to perform a miracle—this was the moment. Since that was not possible, my sense of inadequacy, frustration, fatigue from eight months as caregiver, anger, sorrow, and fear raged through my being with a force that transcended every emotion I had ever known. I was shattered and yet captive of the moment. I had to stay connected. It was like standing with my finger in a live socket taking the volts of electricity and not being able to let go. Together, my daughter and I barely endured another endless night.

The next morning the phone rang. I picked it up expecting it to be my husband. Each day that he was unable to come to Sioux Falls he would call for an update on the status of his beloved daughter. The voice on the other end wasn't his, but rather that of Wanigi Waci.

"Your daughter is very ill."

Hearing the comforting voice of my mentor and friend reduced me to tears and I sobbed, "I know she is, Wanigi Waci, but I have run out of ideas on how to help her."

"If you like, I can bring medicine to her, Jo," he offered.

Little did I know that this offer would take me into another

dimension of health and healing, to a place I had never been before, a place that would explain the appearance of the five stones and the meaning they held for the women in my ancestry.

Introduction

Life is a sacred mystery. Its essence lies in what happens to us while we are busy doing something else. While the predictability of routine fills most days, occasionally we encounter events and circumstances that stand out in stark relief on the landscape of our life journey. These events are the heralding moments in which we come face to face with *who we really are*. It is in this space outside of time that we stop and come to *know* the essence of our being. A journey towards wholeness requires the integration of these significant moments into an exquisite panorama that helps us see the relationship between seemingly unrelated events. Only in retrospect can we trace the path that connects these fragments that stand outside of time. It is this long view that reveals the exquisite

meaning and beauty of our individual and collective existence.

Aside from my strong devotion to a loving Universal Presence and the deep love of my family, nursing has been the great passion of my life. The honor of being a nurse has given me the gift of standing in a sacred space with people in times of change and crisis. A significant illness is transformational, leaving individuals and families vulnerable, with no time or energy for pretense or posturing. In that fragile space I have been privileged to witness incredible acts of brokenness and courage, each beautiful in its own right. In holding space for countless people to explore the meaning that lies embedded within the illness event, both the patient and I have had moments of shared revelation and understanding; both of us become more whole. This was true throughout my entire career until *the patient was my beloved daughter*. Suddenly the holding of space for suffering and reflection became more than I could bear. And when my own strength was gone, a host of others emerged in various dimensions to offer not only healing, but also an understanding that would change my life forever.

This little story is being offered in response to friends who requested it. It is a true story of the love between a mother and a daughter. It is a testimony to the power of the various healing models in society today, and the complexity that is disintegrating the health system that serves us. It highlights the reality that while the physical body may be ill, the cause and meaning lie elsewhere. It reflects the reality that we carry at a deep genetic level not only the color of our eyes and facial features, but more importantly, the core issues of our ancestry. It underscores the power of prayer, love, and relationships in the heal-

ing process. And, finally, it is a tribute to the resilience of the human Spirit as it remembers who we are.

My deepest intention is to share my story as an offering of hope and courage to fellow travelers on this earth journey. Author and philosopher Barry Lopez observed so eloquently that:

> "The stories people tell have a way of taking care of them. If stories come to you, care for them. And learn to give them away where they are needed. Sometimes a person needs a story more than food to stay alive. That is why we put these stories in each other's memory. This is how people care for themselves. One day you will be good storytellers. Never forget these obligations."

I extend a special *wopila* (thank you) to Wanigi Waci, a keeper of the Lakota Sioux traditions, and the Wase Wapka Community who have been so generous in sharing their culture, healing rituals, and the love and prayers of their People. They have encouraged me to write this story and share my perspective of the beliefs that underpin their rituals and ceremony in an effort to build a bridge of understanding and respect between two cultures of healing.

When I expressed concern that I may misrepresent their culture, Wanigi Waci responded, "Your experience is valid and true for you. That is what is important."

What is offered in the story is only my experience and understanding, and in no way attempts to reflect the rich and sacred tradition of this Lakota Sioux Community. I am forever indebted to them for helping my daughter return to life, assuring my grandchildren a future that includes a mother. I also

thank them for my own transformation from a Western notion of curing to a universal appreciation for healing as a movement towards wholeness, irrespective of the physical outcome of the illness event.

I wish to thank Kristi for the courage and commitment to live her destiny and change the heart-scape of the women in my culture forever. From the moment of her birth my life was changed. As she lives I am redefined, and called to become more of who I really am in a most loving and sustaining manner.

I would like to acknowledge some of the kind souls essential to this journey through time. My mother, Florence Goertz, and grandmother, Pauline Schrag, have been the foundation of my life and constant source of inspiration. My father, Reuben Goertz, taught me how to reflect on what is essential for soul growth while adding to the "story" of my heritage. My immediate and extended family in Freeman, South Dakota, taught me basic values and the power of place.

Virginia Weldon, Pam Austin, and Lisa Olson have shown me what it means to be a woman who claims her own power in an authentic way. Soul sisters Maura Fields and Donna Ehrenreich continue to delight me with their own stories and offer encouragement as we navigate our lives in a shared way. Don MacIntyre, Brian Erwin, and Christine Hunsicker have taught me how to believe in a dream and pursue it at all costs.

My husband, Dennis, has offered love and stability in good times and bad. My children, Chip and Kristi, and their spouses, Kathleen and Eugene, give me hope for the future. My precious grandchildren, Kyle, Kahler, Ethan, and Joshua, are my mentors who demonstrate daily how to live in harmony with an

unending sense of discovery, awe, and wonder for the profound and simple pleasures of life.

I would like to acknowledge, with humble gratitude, the presence and compassion of the Great Creator for giving each of us a life to explore and expand our conscious awareness of all-that-is. I am also grateful that S/He has a profound sense of humor!

May any insights gained from this story be integrated into our individual and collective acts of healing and dedicated towards the total health and well-being of a society we are privileged to serve, as we walk the path of the heart.

Foreword

Anyone entering this book Beware: You will be entering new
territory that is both real and surreal; it is magical realism com-
bined with personal story and truth-facing that leaves us
exposed to raw truths and untruths. I have been both inspired
and healed by the reading of this work and feel like JoEllen
Koerner's story is all of our stories. This book invites and
engages one into an intergenerational healing myth and mys-
tery, which is meaning-seeking; it transports, transfixes, and
transcends our customary ways of understanding self, family,
community, and All-Our-Relations.

This uncanny book of altered-state realties and ancient
wisdoms invites and engages us into a story that reads like
ancient myth. JoEllen Koerner, a prominent nurse executive,

scholar, and visionary leader in the field of nursing and health care, leads us by the hand into her personal drama with her daughter and her ancestors; we enter into her terror, her suffering, her despair, her surrender, and finally her triumph. She takes us into the native and ancient worlds of her European ancestors and her Lakota Sioux community in Sioux Falls, South Dakota, making both intergenerational and intercultural connections. These connections open our hearts and minds to deeper dimensions of life patterns, of intergenerational illnesses, symbolic deaths as well as sacred acts that ultimately heal both her daughter and her community, and her Self. Through her process and her pain, deep patterns of ancestral beliefs and practices are interpreted and transformed.

This story crosses and integrates five generations and the mythic passages they each have made into this 21st century. The meeting between multiple worlds carries archetypal symbols and symptoms that required radical healing. A Native American healer escorts the author and her daughter into private spaces and places for ceremonies and rituals that offer intergenerational healing of the Spirit, the Soul, and ultimately the Body. The radical healing throughout this journey is manifest in this prominent author's personal acts of power and personal acts of beauty; personal acts of courage and risk and sacrifice.

This ancient yet contemporary story of women and mothers and grandmothers and great-grandmothers and grandchildren translates into metaphor, legend, and mystery, revealing an epic mythological heroic/heroine journey that ultimately unites and restores harmony among families, communities, and nations.

Thus, JoEllen Koerner's journey and Vision Quest become

our journey and our Vision Quest. Her Native American guide, Wanigi Waci, ushers all of us into the sacred dimensions of life and the dying away of old patterns. This timeless wisdom of indigenous ways awakens us to a Spirit-filled world that transcends conventional minds and mindsets of the modern medical and outer social world.

Perhaps what is most remarkable about this adventure and inner healing journey is that it reveals and exposes broken ways of our conventional medical worlds, while opening new horizons of Spirit-filled possibilities beyond worlds and time. This personally painful, yet joyful, story reads like fiction, redefining, deconstructing, and inverting life and death itself. Yet, ironically and uncannily, these two disparate realities of conventional medicine and indigenous practices unite, and ultimately heal, across worlds and time.

Once we enter into this story, we cannot help but be transformed and enlightened. As we are magnetically drawn into JoEllen's personal story it becomes our story, and thus all of our stories. In doing so, we are all liberated and empowered to open ourselves to new mysteries, wonders, and unknowns that invite Spirit and sacrifice if truth is to be found and healing is to occur. Ultimately this work opens us all to a new horizon of living, dying and healing, re-storying our myths, our histories, and our shared humanity. As JoEllen tells her personal story, we are able to re-think and re-define our lives and ourselves.

Finally, and most importantly, this book is a deeply personal, transpersonal story, and testimony of love and healing with All-Our-Relations. The result: We are all healed by this love story, told by a remarkable mother and nursing leader of our

time. This work is a timeless tale that warrants telling and re-telling; reading and re-reading.

Jean Watson Ph.D., RN, HNC, FAAN
Distinguished Professor Of Nursing
Murchinson-Scoville Chair of Caring Science
University of Colorado Health Sciences Center
Denver, Colorado

A Story of Five Generations

This is a true story, a story of five generations of women in my family lineage. It began in the late 1800s when my great-grand-mother, Katherina, lost her mother as the family migrated to America. The outcome and its meaning were revealed in the year 2000 as my daughter, Kristi, struggled for her life and health after giving birth to a son. It is also a story of all women; the gender that weaves and holds heart-space for a small group called family. It is a story of humanity, the community in which we live, move, and have our being. Finally, it is a love story, a dramatic example of the power of unconditional love, which brings meaning, purpose, and healing to all we touch.

Katherina
MY GREAT-GRANDMOTHER
Generation I

I was five when Great-grandmother, Katherina Waldner Schrag, died. A tiny bird-like woman who weighed eighty pounds soaking wet, she was my first powerful experience of unconditional love. She always wore a long black dress with a tiny white hand-crocheted collar attached. In true Mennonite style, her never-cut hair was pulled up into a severe bun on the top of her head. She had a lap that just fit, and I would spend hours curled up within it, being delighted with stories told in our original German tongue, about the life and times of our people as they lived in "the old country." Katherina had migrated from Russia to America on a ship when she was a mere five years old.

Coming from my ancestral roots of Anabaptist Mennonite faith, she had lived with my other relatives in a colony in the heart of Russia. My people were originally from Germany, known for their hard work and exceptional expertise as farmers. Catherine the Great had invited them to Russia to help settle and develop her new land. They were given very rich soil on which to settle.

These energetic immigrants established a colony which maintained the precepts of their religion: Simplicity (only black and white clothing was allowed along with very strict social mores); adult profession of faith (you had to be an adult when you were baptized as only you, not your parents, could make such a commitment to God); and pacifism (never lifting arms against another person, living in peace with all). German was the only language spoken in the colony, assuring that my ancestors would remain "in the world but not of the world."

Schooling was primarily around the catechism. Only the men received formal education of any kind. A strong patriarchy ruled, with all decisions made by the men chosen for leadership through a strict religious process of drawing lots. A harsh discipline of "spare the rod and spoil the child" guided the relationship with children. Women in this culture were there to work alongside the men in the fields while also maintaining the household, weaving and sewing the clothing, and tending to the family.

While the Anabaptist movement fostered strong community ties and devotion to God, affection and joy were emotions not strongly demonstrated between genders or generations. These cultural norms fostered an arduous life for the women of the clan.

My people were offered political immunity by Catherine the Great, and never required to participate in Russia's wars. Being exquisite musicians, they filled the opera houses in Moscow with their songs and other musical gifts. Over time their farming prowess and privileged status fostered great prosperity, engendering envy amongst other citizens who lived outside the colony and were governed by different rules.

When Catherine the Great died, her son Peter took the throne. He was not of the same inclinations as his mother and immediately removed the previously promised protections. This was unacceptable to one sector of the colony, while the other was willing to make minor concessions so they would not put their position and prosperity at risk. The group who decided on principle to leave all behind and head for America included my great-great-grandparents and their daughter Katherina.

While Great-Grandmother told many wonderful stories of wolves, of magicians who put a hex on those they did not like, and of what life was like for her as a little child, one story stood out among all others. It was the story of her mother's death on the trip to America. With a deep emotion she would tell about how her mother gave birth, became ill and passed away. She would recount the funeral at sea, the way her mother was sewn into a canvas sack for her deep-sea burial, and how the sharks had leaped up and ripped the bag, consuming her body before it hit the water. Katherina would spend the rest of her life motherless, and upon her mother's passing she quickly inherited the task of helping raise the seven remaining siblings. It left a sadness that was palpable until her own death eighty-eight years later.

When the migrating immigrants landed in New York, they were given free passage on a railroad that took them to the end of the line—Dakota Territory. At that time Dakota Territory was comprised of much of what is today North and South Dakota. My people were promised land ownership if they agreed to homestead on it for five years. (I frequently wonder why they did not go on to Iowa where the land is richer and the weather more kind.)

Great-Grandmother saved her best stories for last. It was a magical moment when we visited her home and I found myself invited into her lap, wrapped in a warm crocheted afghan, and held in fascination as she would weave richly detailed stories about unknown people from a faraway land who played such a vital role in my life. She would then describe in detail the first hard years on the plains.

Frequent prairie fires swept the land, burning everything in its wake. Great-Great-Grandfather had the family hold onto a rope and lower themselves down the well as the fire raged over them, saving their lives on several occasions. The first few winters were especially difficult. Inadequate housing for the severe prairie climate coupled with meager crops and food supplies to sustain the family through the long hard winters took the lives of people and livestock. It was the Lakota Sioux Indians, having lived for centuries on the plains, who came with food, shelter, and friendship that sustained these Mennonite immigrant settlers during those challenging beginnings. A deep love and respect between the two groups was born which remains to this day.

As Katherina grew, the American-based Mennonites once again became more prosperous due to their simple lifestyle and exquisite farming acumen. The folks who chose to stay behind in Russia did not fare as well. Slowly those men were forced to participate in the ongoing Russian wars, their land and belongings were taken. Few survived.

Katherina would eventually marry my paternal grandfather, Jonas Schrag, another Mennonite from the Russian evacuation movement, and spend her life in ways similar to the colonized lifestyle in Russia. She died in 1951 surrounded by three generations of descendants, many of whom would carry on the Mennonite way in a manner that fulfilled the hopes and dreams of those courageous enough to venture to the new land.

Pauline
MY GRANDMOTHER
Generation II

In every life we are exposed to a rich tapestry of personalities; people who thrill and inspire, along with those who do not. If we are lucky, the journey includes a few who stand out; they have a spirit and a zest for life that redefines what is possible. This was the stature and spirit of my grandmother, Pauline Schrag Goertz. It was my experience of her that taught me what it means to be a person who lives their capacity with gratitude and humility.

For some, being human is experienced by moving in wide spaces while becoming great. For others the experience of being human comes through staying and connectedness. Pauline was born to first-generation American Mennonites. She grew up in the small rural farming community of 1,000 people that had been homesteaded by Katherina's parents and her own. Her example taught me the art of living simply where we are planted, living an ordinary life extraordinarily.

When Grandmother was five her mother died in childbirth, making her the oldest female in the family. She had to stay home and care for the children, so school was not an option. She taught herself to read and spent her lifetime collecting a "library" (a shoebox filled with clippings) of poems and holistic healing remedies from *Prevention Magazine*. This woman was uneducated by conventional standards but wise in the eyes of those who recognized the power of knowledge gained by embracing and transcending the vagaries of life. She never ceased to display a deep sense of awe, wonder and connection to the subtle mysteries of daily living. Each experience was

enacted as if for the first time, while always she extracted new insights hidden deeply in the familiar. In the 92 years of her life, she never did run out of discoveries in her little corner of the universe!

The Schrag family was quite prosperous as they did well at farming. Her father had great dreams for his nine children. He was upset when Pauline fell in love with a man whose life circumstance was not as fortunate. In spite of family protests, Grandmother married a poor but hard-working gentleman, Peter Goertz. Together they created a life that was rich in love and joy, while not as abundant in financial and material acquisitions. Their union was blessed with a daughter and two sons, one of which was my beloved father, Reuben.

When Dad married my mother she was received into the family with open arms. Mother and Grandmother shared a common issue: Neither one was raised with a mother. This lack of female nurturance and guidance was felt in their interpersonal exchanges. While Mother enjoyed both of her in-laws, she developed a special bond with my grandfather that lasted till his death at age eighty-two.

Pauline was a slight woman, with a smile that carved laugh lines deeply into her beautiful aging face. She was strong willed, imaginative, and had a gift for making each day seem like a holiday. Grandmother loved to be outdoors, finding "women's work" a drudge. She confessed that by not having a mother she didn't learn the fine art of domestic skills. She would quickly do the housework so she could return to her beloved garden where she would graft together various hybrids of trees and flowers. She raised grapes and mulberries to ferment into wine, which was ceremonially served during

Christmas. (I think she occasionally sampled it during the year to make sure it had not spoiled.)

As the first-born granddaughter, I came to know her well. Each Saturday I would ride my bike across town and spend the afternoon helping her prepare for the weekly extended family gathering that would occur every Sunday after church. During that time she taught me what it means to authentically navigate the wonders of the world and claim them as my own. One day when I arrived she was most excited. She had heard that in New York they were making hot pretzels! So we quickly set up the ironing board in her kitchen, took out the flat iron and pressed down hard on the thin stick pretzels she had acquired from the grocery store. Years later, on my first trip to New York, as I walked by the street vendors selling large, steaming hot baked pretzels, her laughter rang in my memory.

She had this wonderful way of "living the letter of the law" without getting trapped in it. All good Mennonites were not to go to movies, dance, or watch TV. However, in her later years, Grandmother got a television so she could watch the Phil Donahue Show. After all, how else would she know specifically what to pray for regarding the well-being of her thirteen grandchildren!

She taught us life skills, such as sharing, in ingenious ways. When giving out ice cream cones the person at the end of the line got the biggest dip. At Grandmother's house, being last was the coveted position.

She showed me the difference between "having it all" and "having everything." She differentiated between her wants and needs, choosing to live life in its simplest form. Material things simply got in the way; she never was a prisoner of consump-

tion. She spent her time and scarce money on living—growing flowers, planting tress, giving to the less fortunate—rather than on material possessions. Her simple approach to life was the ultimate exemplar of freedom. She challenged me to deal with what I was, where I was, and why I existed at all. Though not a saint, Grandmother walked through life with a barefoot soul; authentic, alert, aware, grateful, and only partially at home. Her love of God and longing for "the Promised Land" was the major theme that wove through each day of her life.

I discovered in my shared experiences with Grandmother that power comes from not having, that in scarcity lays abundance. When we are not surrounded or encumbered with "things" we have abundant space for authentic thought and creative action. Since money was scarce she custom-made a board game for us, creating dice by burning dots into a cube of wood whittled by my grandfather. A whole evening could be spent playing "blow the feather over the string," her version of volleyball! And we spent endless hours with our cousins on the front lawn playing the "watermelon relay," spitting seeds and running to them as we raced to the other side of the garden.

Thus began my initiation in the paradox of living: When I stand alone I truly know community; when I am powerless I can make my most powerful choices; the more I know the less I know; by standing in place I can see many realms; my life makes no difference while simultaneously it makes all the difference in the world. Paradox intertwines polar opposites so closely that the heart of one can be found in the other.

I, too, have maintained my lifelong "home" in that little German community in South Dakota called Freeman. We are fourth-generation farmers and ranchers, living on the home-

stead settled by my husband's great-grandfather when he came from Germany. Stability has enabled me to confront the issue of being human with both self-knowledge and self-giving. When I stay with Grandmother's open mind and accepting heart, I discover who I am, and what I am expected to give and learn in the situation. For me, this stability has created a sanctification of relationships, an invitation to live life deeply rather than spend it superficially.

Had I chosen a more transient life I may not have found the inner rhythm of my life. I never would have touched in depth the rich dimension of anything, never stretched beyond myself nor become bonded to others in such a deep and sustained way. Stability has required both acceptance of the human community in which I find myself and my immersion in it. Ironically, stability, as modeled by Grandmother, invited me to grow where I was, in order to be changed. And years later, it was this rich reliance on community that would support Kristi's journey back to life.

Florence
MY MOTHER
(Generation III)

She was beautiful, vivacious, and very popular at Freeman Junior College, a local educational facility that taught young people the arts, sciences, and Mennonite catechism. Mother was the first in the family to get a college degree—a two-year teaching certificate that made her eligible to teach country school in the area. Stories of her experiences as a young teacher fascinated me. She would talk about arriving at school early to start a coal fire and chop the ice off the water bucket

to prepare the room for her nine students. All grades but one were in attendance, so the younger students were invited to sit in on classes with the older children. Christmas was a special time when a homemade stage and curtains would hide eager budding artists and musicians as they entertained their proud parents with original stories and songs.

My father, Reuben, loved to tell the story about the time he went into the college journal office to drop off a story he had written. He saw my mother sitting there in a blue coat and instantly fell in love with her. Nicknamed "Jimmy," my mother had a zest for life and flair for creativity that gave her a prominent place in the social life of the school and the heart of my dad.

Mother was the third child born into second-generation Mennonites descended from the Russian immigration movement. Ten days after my mother's birth her mother passed away from blood poisoning. Grandfather was so heartbroken (he had lost a two-year-old daughter just two years earlier) that he left for California, leaving his newborn daughter in the care of relatives in this small German community. Her first three years were spent moving from the care of one aunt to another, until one day, Grandfather returned. He then married my grandmother's sister, Helen Waldner, and life settled into the routines of this tight-knit community.

Years later Mother married my father, and they also settled in this small German-speaking community surrounded by their parents and a host of relatives. My brother, Richard, was born during World War II, and I came along thirteen months later.

My birth was always referred to as a traumatic moment in the history of our family. During the seventh month of her pregnancy, Mother developed placenta previa (premature sep-

11

aration of the placenta) and began to bleed profusely. Living 50 miles from the nearest health facility, my father quickly transported her to Sioux Falls. After examining my mother, the attending physician informed Dad that he could not save both mother and child. My father would retell the story about how he was forced to choose, and so he chose Mom.

They were able to stabilize my mother, but I was premature in an era that preceded neonatal intensive care units. They wrapped hot bricks in towels and lay them along side my barely three-pound body, fed me milk with a medicine dropper, and for ten days would not allow birth announcements to be sent. Ultimately both mother and daughter survived, and we settled into a new home and a new life in the small rural community that had embraced all previous generations on the prairie.

Thirteen months later my twin sisters were born, leaving my mother with four children under the age of four and none of the modern conveniences we enjoy today. I remember her as busy, efficient, an incredible servant of the community, and yet emotionally remote. Mother was a product of German culture where cleanliness was next to godliness. We would always have to do the household chores before being allowed to play. She was an efficient and wonderful cook, capable of making a feast out of one pound of hamburger. She had the reputation in town of being the first one there with a cake or hot dish when tragedy or loss touched a member of the community.

Mother was incredibly creative and would sew clothes for us out of scraps and hand-me-down materials. I remember the time she made three different styles of dresses out of a pair of curtains so the twins and I would be ready for school. This was no small feat since her sewing machine was an old used one

that broke down frequently. Mom and Dad saved money to buy a new one, but just as the amount was reached the church had a fund drive for a new organ. My father decided it was more important to tithe than to get the new machine, and so the church got the money, much to my mother's dismay.

My brother and I slept in the upstairs attic, a tiny cubicle without insulation. Dakota winters were harsh, reaching eighty degrees (F) below zero during a strong winter storm. Often we would awaken to a line of frozen frost on the edge of the blanket where our breath had been caught throughout the night. We would scurry downstairs and stand in front of the coal stove fire my father had stoked in the middle of the night.

Though I deeply loved my mother, the scars from having no mother in the early years of her life were visible. She had learned well how to please others to gain approval, but I often wondered what she really thought and felt. There was certain sadness in her that would surface in quiet moments. Years later she would tell us that her nickname "Jimmy" was selected from a newspaper cartoon character called "Jimmy the Orphan." The depth of that childhood event influenced her relationship with others and herself in subtle ways for her entire life. It would be Kristi's pregnancy years later, which helped us build a bridge across the emotional abyss that had always divided us.

JoEllen
MYSELF
Generation IV

My mother had always wanted to be a nurse, but there was no school for nursing in Freeman. To keep the Mennonite culture

pure, the young adults were allowed to go to German-speaking school only. So she settled for a teaching career since teacher education or secretarial work were the only two vocations offered to women at the local junior college.

For as long as I can remember I too wanted to be a nurse. My mother's desire certainly influenced me, but I also found great joy in aiding others when they were vulnerable. I would care for stray cats and dogs, tend to the elderly on the block, and read with fascination the *Cherry Ames* nursing book series that was popular at that time. As a child I had an inquisitive mind and came to learn about many great people and exotic places by reading all 200 books housed in our small town library.

We lived in the heart of our small town, in a thriving neighborhood that housed twenty-two children within one block. Needing little sleep, I would often slip out of the house in the middle of the night, climb into my favorite elm tree, and watch the moon and stars. I felt like I could almost touch them, and I wondered what lay beyond the boundaries of my small rural habitat.

Before starting grade school, many times while stargazing, I saw three beautiful angels walking by beneath the tree. I would hear their soft voices speaking or singing, and when I looked down, I could see them as they gracefully passed by. They were beautiful young women with long hair, dressed in soft pastel gowns, surrounded by the most radiant circle of light. Occasionally they would gaze up and speak to me, filling me with great peace.

As I started school and moved into "mainstream society" I forgot about those incredible night visitors. It was years later, when I was faced with a huge family crisis, that I felt a warm

hand on my shoulder in the middle of the night. When I opened my eyes I found these same three angels standing by my bedside, ministering comfort and strength through the ordeal. I believed then as I do now that each of us inherits a cosmology, a set of universal beliefs, from our ancestry, but it is our lived experiences that make them our own. From my earliest years, I have always sensed at a deep level that all of us are multidimensional beings, and that belief has richly guided and informed my life journey.

My childhood was spent living in the small town of Freeman, supported by two sets of grandparents and a rich family life. Father was a brilliant man who loved my mother and his entire family clan very deeply. He was offered a scholarship to attend the Mennonite Seminary, but as the firstborn son, he knew it was his duty to stay home and care for his family and his parents. So he declined the opportunity to expand his marvelous mind with formal education, and became a clerk in the local lumberyard. Because the job demanded so little of him intellectually, he was very creative at home.

He taught himself photography, and I have many fond memories of developing pictures in his darkroom late into the night. He was inventive, making a bicycle built for two by welding together the front part of an old red bike and backside of a blue one. While we did not have much money, there was plenty of activity to keep life interesting in a wonderful way.

My favorite activity each year was a summer event called "The Vanishing Trails Expedition," sponsored by the Center for Western Studies. A car caravan of several miles in length would meet in Wall, South Dakota, for a pancake breakfast, spending the day wending down lost trails in the western part

of the state. I loved the trip because it would always take us to a Native American reservation where we would visit the gravesites of brave warriors who had done amazing things for their People. I loved the stories the Native Americans told about their culture and their land. Those stories always disturbed my father, so we would go home and read books like *Black Elk Speaks* and discuss the injustice done to the people who lived on the land long before our ancestors arrived.

My father was the one who noticed that I had a restless mind. He would bring me books and magazines to read, and we spent many hours discussing what the author might have meant. He even created a "reading room" for me in the garage attic, placing raw planks for a floor and an old rejected mattress as my lounge.

One cold winter night I was unable to sleep and climbing my favorite tree was not an option. My father sensed my being awake and invited me for a walk. We bundled up in winter woolens and walked from the edge of town down to the local cemetery. The moon was brilliant, and the cold blue snow squeaked beneath our boots as we walked in cadence, pondering the big questions of life. He had a very philosophical mind and the courage to challenge conventional wisdom without rejecting it. From my father, I learned the value of openness and the richness of multiple perspectives.

Music was the most meaningful pastime for the entire community. The musical gifts of our Russian ancestors were not diluted in this close-knit community. In my family we all learned to sing and to play piano and several other musical instruments, and we spent many family evenings playing together. My sisters and I formed a trio and were featured

at many regional events. We were invited to audition for the "'Lawrence Welk Show" television program, which we declined.

Unfortunately, my favorite instrument was the pipe organ. I loved to play, but it was housed in our church seven miles out of town. Since we had little money, there was no way to pay for lessons. So I created a barter exchange with one of the most outstanding organists in church: I would teach her Sunday school class if she would give me lessons. I went home and put tape on the floor in front of the piano where the foot pedals would be, and I practiced every day. Then on lesson day, I'd pedal to church on my bike, practicing till she came and long after she left. Occasionally when I could not sleep at night my father would drive me out to the old North Church. He would curl up on a hard wooden pew as I played Bach music to my heart's delight. Some the deepest communion between my father and myself occurred during those times, often without a word being said.

Living with my brother (the firstborn male in the generation) and twin sisters (a novelty in the community), I experienced middle-child syndrome, frequently playing the role of the peacekeeper or "the good one." We had the usual joys and struggles that most siblings encounter, but my main memory of them is that we were always there for each other. Mom and Dad loved each other very much, so while we were poor by conventional standards, there was a richness and security in our family life that helped me develop a sense of trust in the unfolding process of life.

After graduation, I fulfilled my Mennonite voluntary service obligation by spending the summer of 1964 in Gulfport,

Mississippi. It was the summer that the Civil Rights Bill was passed. I was part of a group of sixteen Mennonite young people from across the United States who volunteered to build a recreation center for an African-American community. As the bus took us into the heart of Mississippi I was stunned to see entrances of stores, restaurants, and restrooms marked "Whites Only." It was a summer of violence, prejudice, and exposure to a world so far removed from my previous life that it opened me up to the larger universe in a profound and jarring way.

Ours was a racially mixed group, with multiple cultures represented. One day we went to the Saint Louis Zoo and boarded the train that took visitors through the park. Because our group included African-Americans, we were all thrown off the train and banned from restaurants.

The gulf was across the street from the dorms we lived in for the summer, and after work we would go swimming in the water and play along the beachfront. Two days after our arrival, our counselors told us we were not to go to the water because they had received hostile phone calls. That night, and for several nights after, angry men with dog packs came through the area yelling obscenities and threats to our lives.

In sharp contrast, during the weekends we taught Sunday school in the local African-American Baptist Church. The children and parents were delightful, and accepted us in such warm fashion that it made the racist Caucasian aggressors' behavior totally irrational and untenable. I had witnessed hatred and bigotry on such large scale that my commitment to equality was ignited in a way that carved the foundation of my life's path deeply. Later, as a nurse executive, this lesson fos-

tered my deep commitment to shared governance as a vehicle to place opportunity and accountability directly into the hands of the nurses who truly lived "the work" of the profession.

I returned from Mississippi in the fall of 1964 and pursued my lifelong passion of becoming a nurse by entering Sioux Valley Hospital School of Nursing, in Sioux Falls, South Dakota. My high school sweetheart, Dennis Koerner, was a business major at Sioux Falls College. We married during our last year of school and I began working on a medical unit at Sioux Valley Hospital while Dennis finished college. His heart, however, was in the land, and after graduation we found ourselves returning back to Freeman as fourth-generation farmer-ranchers on his ancestral homestead. Once again I was surrounded by the women of my Mennonite ancestry, but with one difference. I had been "out in the world" and had experienced the mind-expanding impact of a broad formal education and the richness of a professional career. The lifestyle and tradition that had served them so well stifled me.

I had loved my initial experiences as a nurse; it transcended all expectations I held for the profession. As with all new graduates, I began on the night shift on a medical floor that served patients who were older or underserved. We typically received people with a health challenge that had not been diagnosed, so their anxiety was high when they arrived. One patient in particular gave me my first profound lesson in what it means to be a nurse.

I had been on the floor for three months when Mr. Green was admitted to the unit, a forty-four year-old male with unexplained bleeding from the nose and gums. He was a delightful and energetic man who was a pillar of strength for the small

community in which he lived. President of the Chamber of Commerce, CEO of a thriving business, and father of three delightful children, I had the privilege of settling him for the night when everyone else went home.

Being present to people in crisis is a privilege that humbles me. In the dark of night when they are alone, many individuals find that they are confronted with their mortality. It is a time of profound introspection and evaluation, a time of sorting and sifting through their lives in an effort to make meaning of the events which have been their lived experience. It is also a time for the fears, the regrets, and the secrets to be acknowledged. I have noted that the greatest fear we hold as humans is the fear that we will die without having been known. Through my many years in nursing I have discovered the secret gift of nursing: The chance to bear witness to people in crisis sorting through their lives, offering safety and unconditional regard as they bring completion to issues unresolved, or not understood. The person who learned most in the process was always myself.

Mr. Green proceeded to tell me that he knew he had a terminal disease, that he was dying, and that his greatest fear was how his wife would care for three young children. We had done no diagnostic tests, and yet he knew, as many people know when their time on earth is ending. One must never argue with the patient; their knowing is perfect. In the next three days a diagnosis of fulminating leukemia was confirmed, and Mr. Green was given six months to live. He received several blood transfusions and was sent home.

In the next few months Mr. Green came in for repeated blood transfusions, and my relationship with him and his family deepened. He had his 45th birthday on one admission,

and I reserved the nursing chart room for the family. One of his sons had told me that his father's favorite pastime was fishing, so we decorated it with outdoor scenes, made a fishing pond, and invited his family and business associates in for a fishing derby with silly prizes, cake, and ice cream. Within the next few weeks his admissions became more frequent, and his demise was eminent.

At that time I got promoted to a critical care unit that had just opened on another floor, and I thought I would not see the family again. One week into my new position, I was startled to see Mrs. Green standing at the nurses' station.

"I have looked everywhere for you," she said. She proceeded to tell me that Mr. Green had been admitted, and they all knew it would be his last admission. She held my hands and pleaded, "I don't want to be alone with him when he dies. Will you come and sit with me?"

I had grown so very fond of this family, the thought of witnessing his death broke my heart, but I quickly said, "Of course, it would be a privilege to sit with you."

I called the evening supervisor, an incredible mentor and colleague, who offered to cover for me when the time came.

In the middle of the night Mrs. Green appeared, and I could see by the look on her face that her husband was dying. We went into his room and sat by his side as his breathing grew slow and soft.

As he was slipping away I told her, "You can touch him, and tell him how much you love him."

She pulled herself into bed, and lay beside him, telling him what a wonderful husband he had been, how much she loved him. She gave him a kiss and then he was gone.

We both wept as we gently cleaned his body and prepared him for viewing by the children. Then she called her family in to say goodbye to this wonderful, gentle soul of a father and husband. Watching the love and tenderness between them all taught me a great deal about how to die with dignity. I thought I would never see them again.

Several months later I was working the day shift and was called to the nurses station. To my great surprise and delight, there stood Mrs. Green. She was all excited because she had just been accepted into nursing school. The death of her husband made her decide it was time for her to do something with her life, and nursing was her chosen field. She commented on the powerful exchange we had shared when her husband was ill. It was something she wanted to offer others and the reason she enrolled in school. The next time I saw the family I was sitting with them at her graduation exercise. The meaning of a tragic loss had been made clear in her life.

Leaving that meaningful work for the life of a farm wife was very challenging for me. I quickly learned how to gather, clean, and pack eggs for sale, how to raise baby chicks and pluck them when butchering day came. (I never could bring myself to kill them, so I would catch them in a crate and drive to the neighbor who would do the job for me.) I walked bean fields pulling weeds, stacked bales of hay, and cooked for the harvest crew, but my heart was not in the work. So, Denny and I determined it was time to bring children into our lives.

The Vietnam War was just beginning when we decided to start a family. Our first pregnancy ended in a miscarriage, and the loss was heartbreaking because we had such a desire to be parents. It was Christmas Eve when we lost our second preg-

nancy, which was devastating. The specialist I was seeing told us we might never carry a pregnancy to term, and the irony of hearing that news on the birth day of Christ was not lost on us. Dennis was drafted three months later. We discovered that I was eight weeks pregnant as he left for Fort Pendleton, Missouri. I would not see him again until the twins were two months old. Though he was never in combat danger, an outbreak of spinal meningitis took the lives of two of his colleagues in boot camp. We frequently connected by phone, but a long-distance relationship does little to help soften the loneliness of a woman living with all the changes and challenges of pregnancy! I lived alone until the final trimester of my pregnancy when my doctor advised I live with someone in case complications arose. I moved in with my parents.

This pregnancy was medically managed with multiple pharmacological interventions and an exceptional obstetrician. With the help and support of my parents and grandmothers, the pregnancy was maintained. Twins, Christopher and Kristi, were born beautiful and healthy, fostering in me a sense of profound joy, wonder, and gratitude. Adding further to my joy, Dennis arrived home on Mother's Day to see and hold his children for the first time.

Life became filled with the richness of raising children while sustaining a farm and ranch operation. For the first three years of their lives, I immersed myself in the role of wife and mother. The twins were surrounded with a host of dogs, cats, piglets, rabbits, gerbils, fish, and baby calves. They had every imaginable critter to play with, and of course, they had each other. Watching them grow in close connection to each other and nature was one of the most gratifying periods of my life.

However, as they got older, the longing for my nursing career would not be quieted.

One day Dennis came home for lunch at noon with the harvest crew in tow. He walked into the kitchen and found the table unset. I was sitting on the living room sofa unable to move. Concerned, he asked what was wrong.

"Dennis, this is your life, not mine. When we married I thought we would be living in the city with you in business and me in nursing. When we came back to the farm I tried to make it work, but my heart is not here. I miss the patients. I miss my colleagues. I miss having the challenge of making clinical decisions. The deep longing of my heart will not be quieted. The twins will start school this fall, and I do not know what I will do."

It was one of the numerous unsettling moments that Denny and I would face as we tried to sort out our truth from tradition. We decided that I would return to work several days a week, and the money made would be used to hire someone to help Dennis at home. That way both careers could continue in ways that were meaningful to each of us. And so, when the twins started kindergarten, I began working in the local rural medical clinic two days a week.

Those early childhood years were filled with 4-H projects, camping adventures with our pop-up tent, and trips down to the river where we would gaze at the colony of our Mennonite ancestors, grateful that we had the freedom to live such an expansive life. Chip was an athlete, and Kristi an artist, so we attended almost all events the local school district hosted. The special relationship between the twins was an amazing gift to watch—aside from the time when they reached driving age,

that is. Chip announced that in no way was he ever going to be seen sitting in a car driven by his *sister*! Kristi, on the other hand, declared that she had as much right to the car as any male! So I told them that unless they could figure out a compromise, they would continue to ride the school bus instead of taking the car to school. In short order they decided that Kristi would drive in the morning, and Chip would drive the car after school (when all the cruising through main street occurred). It was only one of many moments when the two of them would struggle to find middle ground. To this day, their ability to negotiate a mutually agreed upon position far exceeds my own!

As a family we wove our personal and professional lives into a tapestry that did not resemble the lifestyles of previous generations. Once the twins started grade school I worked as a nursing educator, my work hours mirroring their own. As they entered high school I began to work back in Sioux Falls, where greater job opportunities called. This provoked some criticism and judgment from the traditional side of the Mennonite community.

The German maxim "Cleanliness is next to Godliness" held great sway in our small corner of the world. Every Saturday was cleaning day for me, with each of the children having their own assigned household chores. Once I started working in Sioux Falls, it required a 100-mile per day commute. At that same time Kristi had developed such capacity in her flute playing that she was encouraged to take lessons with a special tutor at a Sioux Falls college. I would make my sixth trip of the week to Sioux Falls with her, thus cutting into my cleaning time.

I told Dennis it would make sense to hire a cleaning service. We put an ad in the paper "Cleaning service wanted twice a month. Call 605-555-4333." Within the next week the phone rang frequently. When I would answer, "Koerners," there would be a click on the other end as the other party hung up. And shortly after, the word was out that it was the Dennis Koerners who were hiring a cleaning person! Luckily, our extended families were supportive of our lifestyle, and the rhythm of life settled into a harmonious cadence.

One day the twins came home from high school, telling us they had been called into the principal's office. His wife was considering going to work, and he wanted to know from the twins what it was really like to have a working mother.

I held my breath as I heard them say, "We told him it's really cool, cause when we need her she's always there. And we learned how to iron our own shirts, schedule our own piano lessons, and we can manage our own lives!"

The twins grew into beautiful young adults, and soon thereafter left home for college. It was after their departure that my whole world fell apart, and came together in a new and amazing way.

Kristi
MY DAUGHTER
Generation V

She was tiny, pink, and very fragile. Kristi lay in her crib quietly surveying her new environment. Even then she held up her hand, extending her little finger in regal fashion. Two dimples, a soft tuft of brown hair, and my heart was hers forever! As Kristi grew we shared many tea parties wearing big hats and

white gloves. When Princess Diana was married in 1981 we wrapped in blankets at 3:00 A.M. to witness the ceremony. She was my daughter, my soul mate, my other.

Her brother, Christopher (Chip), was much like his father, a shadow to Dennis. He was second born, starting life with a vigorous cry and protest at his change of circumstance. Without a word exchanged, he and his father moved in harmony with the land, exhibiting qualities that had existed in the family for generations. From his earliest moments, Chip would bound out of the house with a spring to his step and an eagerness to get his hands into the work of the day. He demonstrated a special capacity to build and maintain machines and equipment without looking at the instruction manual. He had a special affinity for animals that allowed him to excel in 4-H. Colleagues would ask him to show their cattle at the county fairs because the critters calmly would follow his lead. When he had to come in for the night, or even worse, go to school, a little light went out of his soul. He would not be whole until he was connected with the land once again. Many years later, as a successful civil engineer, he saved up his vacation days to come home and help with planting and harvest. The land that birthed him, and the many generations before, defined the cycles and seasons of his life. Those qualities I so loved in his father were precious in this fine son of mine.

Kristi was sensitive, beautiful, and incredibly intuitive. When she was barely four I had a teaching colleague over for lunch.

Sandy said "Kristi, how are you today?" to which Kristi responded, "I'm fine."

Then she looked at my colleague for a moment and asked, "And how are *you* today?" really meaning it.

The intensity and sincerity of that query was a pattern that would repeat itself throughout life. It drew people to her, and she often found herself serving as a sounding board for others to process issues and concerns.

She had a special capacity for music, a reflection of a gift inherited from her German-Russian ancestors. She progressed so rapidly in playing the flute that the school music instructor encouraged us to provide Kristi with special lessons in a town fifty miles away. Every Saturday she and I would drive to Sioux Falls to take her flute lesson and return home to watch an old musical video on TV. We loved the sounds and the staging, imagining that we were Ginger Rogers dancing with Fred Astaire.

It was during those trips to the city that I noticed something unsettling. When I would drop her off at the campus building for her lesson, she would not enter it until she could see me park the car and walk towards her. Only when I was near the building would she turn and go inside. Often I would ask her what she feared, but she had no explanation for it. At times she exhibited a deep sadness that had no name. Albeit fleeting, it was a painful thing to observe.

Her ear for music made learning languages easy and she excelled in German. It was the great delight of my parents that a grandchild could speak their native tongue. They spent many enchanted moments sharing stories and memories in our family's second language, and a special bond was born between them. During her childhood I had the privilege of watching the world through the lens of four generations of women living in the same town. It was then that I came to realize that while we all shared the same space and the same family, no two of us shared the same worldview!

An example of this surfaced when The Center for Women at Sioux Falls College hosted a "Take Back the Night" march in early spring of 1989. The march was a call for increasing safety for women. I invited all the women in my family to join me for the event. My grandmother, who had spent her entire life in the small Freeman community, population 1,000, could not understand that there was an issue of safety for women. My mother said she simply could not march because she feared what her friends might think of her—they may infer that she had suddenly gotten to be a feminist or some such radical thing. Kristi was in high school, and had never marched before, so for her this was an exciting new adventure. I was quite excited about the event, remembering all the causes we marched for in the early 1960s, and I was reminded again that we truly are products of the era into which we are born.

After graduating from the University of South Dakota in Vermillion, Kristi was selected by MCI as a Gold Scholar. One of ten selected nationwide, she was placed into an accelerated management program that moved her to various parts of the country. After several years in corporate management she accepted a position in Germany, reconnecting with the heritage she had come to know and love so well. I missed her deeply while she was gone.

Late one night, while she was living in Germany, our phone rang. It was Kristi.

"Oh Kris," I exclaimed, as I looked at my watch showing 3:00 A.M. "What's wrong? Are you okay?"

Her soft laughter filled the phone as she explained that she was just lonely. That day a mother and daughter had come into the shop where Kristi was working as a summer intern, and as

she watched them she felt a longing to connect with me. She then proceeded to thrill me with tales of her life and the insights gained. I was amazed at the depth of understanding and breadth of her experience.

"I just don't get it! You, at age 24, know more than I do in my 40s. How wonderful!"

She then gave me one of her many loving gifts when she replied, "Oh, Mom, it's just because you've been a cool mom, and I don't have all that 'unlearning' to do."

Kristi had dated periodically throughout high school. She dated one particular young man throughout college and became engaged to him towards the end of her senior year. When she brought him home for the first time, her father and I were concerned by what we saw. When you know your child's soul, you can see when it is vibrant with joy and when it is simply holding space. There was no passion or delight in the relationship; it appeared more like a friendship based on similar interests. Happily, she ended the relationship before graduation; the fit was just not there.

Several months later I was in my office at Sioux Valley Hospital when she came in with a young man to pick up some materials for her school project. As they walked out the door I said to my colleague, "She is going to marry that man." I could see it in her eyes and sense it in her heart.

Two years later Eugene Welch and Kristi were married, changing her world in ways none of us could have imagined.

The Meeting of Two Worlds

The path from my sheltered Mennonite community into the larger world unfolded slowly. When the twins were born I left nursing to become a full-time mother. The Vietnam War ended, the economy was strong, and we quickly fell into a rhythm of life in sync with our small farming community. Enjoying the twins after the loss of two miscarriages, I often would find myself standing in their room at night while the they were sleeping, reveling in the joy of their presence. I would lay them on opposite ends of the crib. However, by morning they were always lying side by side, holding hands. That closeness between them remains to this day. Those first

years of their lives were busy and fulfilling. It was a sweet and simple time.

As they climbed the school bus on their first day of kindergarten a new chapter began. I had the tape recorder running when they came home to capture their report on the happenings of the day. Though they were in the same school and classroom their stories were so widely divergent that I could see that their lives would take very different paths. Once they went to school, I returned to clinic nursing two days a week. Later I was invited to lead the Nursing Department at the junior college where my father and mother had met. My hours mirrored those of the children. The summers were spent living farm life, grooming 4-H critters, and enjoying family vacations. Their childhood passed quickly before my eyes.

When the twins got to high school I was surprised by an invitation to the position of Statewide Education Consultant for the South Dakota Board of Nursing in Sioux Falls. I had been busy with my administrative position at Freeman Junior College when a new nursing dean arrived at South Dakota State University. She was eager to establish a Masters in Nursing program for South Dakota, as we badly needed this level of educated nurses to fill faculty and administrative positions throughout the state.

The Chair of the Appropriations Committee for the South Dakota legislature was a neighbor who lived four miles down the road. The dean called and asked me to lobby him for funds to establish the program. I drove to visit him, explaining the situation. He quickly assured me he would vote "yes" on the issue, and I happily relayed the conversation back to the dean. Much to my dismay, when the final vote was tallied he had

voted "no!" I was dumbfounded, still naive about the ways of politicians; I had taken his word as truth.

The scene was reenacted the next year, only this time I told him that I would be watching his vote carefully. I also hand-delivered a petition requesting his support that I had circulated among all of "Who's Who" in our small farming community of 1,000: The president of the bank, the head of the Chamber of Commerce, the CEO of our small hospital, the president of the junior college. Furthermore, I told him that if he voted no, I would personally run against him in the next election (which I had no intention of doing!).

Much to my delight, he voted yes, and we received the funding needed to establish the Masters in Nursing program. He then went to the governor and asked him to please appoint me to the Board of Nursing because I was making too much trouble in Freeman!

The governor's appointment moved me back into a professional arena that reached beyond Freeman. I was once again sitting with colleagues from across the state, examining issues that influenced quality of care for citizens and quality of work life for nurses. It was during my tenure as a board member that I was approached by the executive staff to consider taking the educational consultant position with them. My husband and I carefully reviewed the impact this opportunity would have on our family life. We both decided I should take the position, and thus began a commute of 100 miles per day.

It was a wonderful time of working with educators throughout the state who were striving to maintain standards of excellence in geographically remote areas with limited resources. One such program was a Sioux reservation-based

nursing program. Our site visit underscored how challenging it is to impose Western medical criteria and learning models onto a culture so fundamentally different in every way. I left the reservation with a deep appreciation for the values and healing traditions that were being woven into the required scientific curriculum, and I felt that it was *our* knowledge base that was incomplete.

Harsh South Dakota winters made the daily trip to Sioux Falls a challenge, but it brought me back into the nursing world I so deeply loved while providing the family with needed insurance and income for looming college expenses. All too soon the twins' high school graduation party was celebrated, and the farmhouse fell quiet once more.

Sioux Valley Hospital

The first vice president for Nursing at Sioux Valley Hospital was on the South Dakota Board of Nursing. A giant in the nursing world, Mary Schnelker had just been elected president of the American Organization of Nurse Executives, which is also known as AONE. Mary was in her mid-forties and had already had a rich and illustrious career with a track record for moving a traditional nursing staff into a 21st century professional practice community. She had been hired by Sioux Valley Hospital two years prior to our meeting. With awe and fascination I watched as she placed nursing at the corporate table. Her unique blend of theory and practice had redefined the possibilities within the profession as no one else had done within this conservative state.

One day she appeared in my office and announced,

"JoEllen, I am about to leave and you need to come and take my position."

I looked at her with disbelief. "I know what I don't know. I have had a rich career in nursing; I love it with all my heart. But I have not had corporate experience and I know nothing about budgets and staffing."

This dear and wise mentor smiled and gave me a most profound piece of advice: "Be clear on the difference between inability and inexperience. You have not had this experience but your entire life has given you the abilities needed to successfully lead the nursing practice. You will be coming home (she knew of my career beginnings at Sioux Valley Hospital and my deep love of the place). People from your past are still there, such as, the head of the school of nursing, and the CEO. Many will help you, and you can contribute back to the health and well being of the people in a state you love dearly."

Sioux Valley Hospital is the largest acute care hospital in the state. It was the place of my birth. It was also the home of my professional birth: I was a graduate from its diploma school of nursing, and it had given me my first position as a new graduate. It was also the place where the twins were born. Sioux Valley Hospital was a big part of my life and my affection for it knew no bounds. The thought of returning there to work with the wonderful people within it was enticing.

"Why would I take such a position?" I asked myself. I knew the issues were complex and the work difficult, but I also absolutely believed that every nurse who chooses the profession as their career path has a sense of calling and a desire to serve. Mary had developed a wonderful framework for professional practice, and I was being given the opportunity to truly

learn more about the essence of nursing from one of the finest nursing communities in the country. The thought of what we could do together to enhance the health of a rural, sparsely populated state with a disproportionate percentage of elderly and nine Native American reservations was enticing.

I quickly found myself in a series of interviews and was ecstatic when I received the job. A farewell party for Mary Schnelker soon followed, but her presence has lived on within the institution. To this day she remains a most loved and prominent presence in my personal and professional development.

The first year was a whirlwind of learning: New faces, new tasks, new challenges, and new opportunities. The CEO had been there for almost thirty-five years, with his COO of similar longevity. They had a love for the community, a respect for professional practitioners and always, always kept the patient at the center of every decision. The entire organization was filled with wonderful people committed to caring, but the world within that I knew best was nursing. The exquisite nursing practice at Sioux Valley Hospital taught me what it means to be a nurse.

An example of their dedication was shown during a four-day whiteout blizzard. The governor had closed the interstate because of zero visibility. All traffic was stopped, while accidents continued in unprecedented numbers. Snowmobiles and 4-wheel drive vehicles were able to bring enough nurses in to the hospital to cover the shifts, but we ran out of beds because we could not discharge the more stable patients—they had no way to get home. We rented a wing at the Holiday Inn, and the stronger patients and their families were housed there with a cadre of nurses who stayed with them until the storm sub-

sided. We ran out of bread, pharmaceuticals, and supplies, but still the nursing staff was able to keep patients safe and comfortable throughout the storm. This kind of dedication and devotion was the hallmark of Sioux Valley Hospital care.

Their commitment to caring created a professional practice model that redefined the role of nurse and empowered the patients. They established a shared governance model of management, creating a senate to oversee the work of the practice. Thirty-four members of the staff wrote a book entitled, *Differentiated Practice: Transformation by Design,* and I fondly remember the auditorium being filled with family members and dignitaries at the official autograph signing party. After their book was translated into Chinese, a delegation of clinical scholars from China came to the United States to study at Johns Hopkins University Hospital and Sioux Valley Hospital. This groundbreaking work attracted visitors from all over the country and various parts of the world. It was the most magical professional time in my entire career.

The fine work of the nursing practice caught the attention of others. I was honored to be elected as president of the American Organization of Nurse Executives, a group comprised of nursing administrators and managers throughout the entire country. It was during my time as president of AONE that the Clinton Administration was working on health care reform. I was frequently in Washington, D.C. for meetings, and I noted, with despair, that the public dialogues about what was needed were being attended by lawyers, medical purchasers and providers, and large hospital systems, with an occasional physician added to the debate, but not one nurse or consumer.

Simultaneously, I was meeting the most incredible nursing

professionals, both in administrative leadership and clinical practice. They held such wonderful stories and insights of techniques that were less expensive, more effective, and more empowering to the patient. I realized that if nurses were to influence social policy at the political tables, we needed to be armed with enough experience, positive patient and healthcare system outcomes, and credentials to gain visibility and voice. I decided to go back to school for my doctorate in nursing.

This decision made my husband and me carefully review our roles and responsibilities. Along with the financial challenges, there was the issue of time – and a sense of concern about what this might do to our relationship.

My mother took me aside and said, "Jo, when you went off to school to be a nurse I was so happy for you. Then you went to get your teaching degree and it made me proud. But why are you getting a Ph.D.? I worry that you will be so smart that you won't be able to get a job, you won't have any friends, and you won't have time for us anymore." She had just articulated the fears and restraints placed upon her generation of women. I looked at her tenderly, for in those comments I heard how much she really loved me.

I enrolled in a very well-known university on the East Coast. It was one of the first in this country to offer a nursing doctorate. Every month I was to fly from South Dakota to New York and spend the entire weekend studying with colleagues. Much to my dismay, the entire semester felt and sounded like a repeat of past learning. I was hungry for something more flexible and expansive. During that time we had a consultant who was helping facilitate a large project at Sioux Valley Hospital. She had the most unusual way of looking at things.

I asked her, "So, what do you read to get the perspectives that you have?" I assumed her distinctive points of view originated with the information she took in.

She laughed and said, "I think this way because of the wonderful education I received at the Fielding Institute."

She proceeded to tell me about an amazing adult learning program that required students to co-create their learning plans, which had to be based in their professional work. Part of the application required writing an autobiography—and you got extra points if you were a maverick. It sounded like a perfect fit.

Fielding was my first true venture outside of South Dakota. Located in beautiful Santa Barbara, California, it included over 1,000 students from all over the world. On our faculty were national and international experts on the topics being studied. Being in this environment felt like stepping into an oasis after a long pilgrimage through a dry and arid desert.

I structured every course around the health care industry and my beloved profession, nursing. Once I took a course called Social Action, designed to teach a research method where the people who were being studied actually designed, ran, and interpreted the data. Our professor came from Switzerland, and he had used this method in leading the World Bank's transition from bank tellers with paper and pencil to a fully automated system. His story was fascinating and left my classmates and myself enthralled.

In the afternoon the class returned and he asked each of us what brought us to the class. Then he selected two students for an in-depth dialogue: Vasu from India who was working on Third World hunger, and myself, as I was working on facilitat-

ing the nursing practice transition to Shared Governance. Vasu and I were invited to sit on two chairs in the center of the room, surrounded by our classmates.

The professor began with me. "JoEllen, how did you start your project?"

I described the way a nursing subcommittee ran a literature review to obtain the best practice and expert opinions in the field. The subcommittee then established group norms, shared assumptions, and assigned committee and task force structures to manage the project.

He turned to Vasu and said, "So, Vasu, what did you do to start your project?"

Vasu chuckled and said, "I invited in a guru."

I gasped, "A guru? Vasu, what is a guru?"

He looked at me with serious deep brown eyes and said, "One who knows."

I replied, "Vasu, are you a guru?"

He grinned broadly and said, "That is why I am here—I am a guru in process."

At this the whole classroom twittered with nervous laughter.

As I regained my composure I said, "That's really not fair. In my country we work with skeptics, while in yours it is a group of believers!"

A roar of laughter ran through the group. We spent the rest of the day looking at two distinctly different worldviews about how to manage change—and amazingly—we both ended up at exactly the same place.

My years at the Fielding Institute taught me how to facilitate learning from the context of the learners, their work and their world, rather than starting with a subject where a faculty

member predefined the learning. One size does not fit all. My exposure to so many different learning cultures expanded exponentially my capacity for inquiry and reflection. I left the Fielding experience determined to find a way to make such rich learning available to others, for it had literally transformed my life.

Back home, I was blending my learning experience at Fielding with the wonderful perspectives gained from AONE. At Sioux Valley Hospital, where a powerful clinical practice model had already been created to provide quality care, I was able to turn my attention to an issue that had been buried inside of me for many years—the health of the Native American people in our state.

Statistics from the Indian Health Service indicated that the reservations of South Dakota had the second highest death rate in the world, second only to Central Africa. The incidence of diabetes was 400% greater than the general American population and Fetal Alcohol Syndrome was experienced by one of every five children, while the national rate was less than one per one thousand. Suicide among the young people on the reservation was rampant. The statistics were a strong indictment against the health care provided in the state.

To this day, according to the most recent statistics from IHS, the health of American Indians is far worse than for any other minority group in the United States, and the Sioux Indians in South Dakota have the poorest health statistics of any Indian population in the United States. Their average life expectancy is 46.2 years, versus 56.3 years for all Native Americans and 75 years for all Americans. A number of factors contribute to their poor health. Native Americans highly dis-

trust Western medicine, which discourages them from seeking preventative care and does not acknowledge the healing practices of their culture. Inadequate funding of Indian medical care is also a perennial problem. Health expenditures per person in the United States is $3,820, but only $1,576 per American Indian.

There are few trained physicians on the reservation and often their care practices are at odds with those of the indigenous healers. There is limited access to health care due to poor transportation and remote living conditions. Poor health practices, eating habits, and little understanding of the effects of lifestyle choices on health foster a high prevalence of diabetes and substance abuse. These and other health conditions were, in part, the result of the Native Americans being forced into reservation life where their native diet was replaced with foods that are best suited for a European genetic makeup.

Most of the treaties between the United States Government and Indian tribes agreed that the federal government would provide adequate medical care for Indians in return for millions of acres of land, with Indian Health Services as the administrative agent for dispensing care. Unfortunately, over one hundred years later, the appropriation of funds continues to be inadequate to address the Native people's needs beyond the most dire of emergencies. Mortality statistics are worsening over time, and preventative programs are almost non-existent. There is little hope for increased funding for Indian health care, which is why *the health care industry must address this disparity* in creative and collaborative ways.

My heart became heavy as I reviewed the hospital statistics on the American Indian population we served. Here I was

enjoying a life of beauty, freedom, and choice, while the people who had saved the lives of my ancestors were living in poverty and ill health. I talked with my father about the issue, and we decided it was time to raise the consciousness of South Dakotans about the significant role the Lakota Sioux had played in helping our ancestors settle the Dakota Territory.

My father was a self-taught historian and a consummate storyteller. He had gathered literally thousands of pictures and stories of the Germans who migrated from Russia. His work captured the beloved odyssey of my people. He was a well-published author and speaker who traveled all over the world telling this story. (Upon his death, Augustana College Center for Western Studies created the Reuben Goertz Scholars Room to house his collection.)

We decided to research the story of how the indigenous people of the region provided safety, food, and shelter for early European settlers to the area. It would be published and told through multiple venues as a consciousness-raising effort.

Tragically, he died from an aortic aneurysm three months before our scheduled time to begin the project. Deep in grief, I decided that instead of rewriting our history it was time to write a new chapter. Thus began a journey that would lead me to Wanigi Waci (Spirit Dancer) and the Wase Wapka Community, the healers who would ultimately help Kristi back to life and health many years later.

The Lakota Sioux Community

The Sioux Indians in South Dakota are struggling not only in their health statistics, but economically as well. Their financial

well-being trails that of citizens of many Third World countries. The economic disparity between the Sioux and the rest of American society is growing. Per-capita income in the U.S. is $13,467, while reservation income hovers at $3,350. Treaties forced the Indians onto land with few natural resources and unproductive soil. Essentially, there is no industry to support employment on tribal lands, and banks will not underwrite reservation loans because of difficulty obtaining collateral. Unemployment in the United States is 4.7%, while reservation-based Native Americans experience an 80% unemployment rate. A student dropout rate exceeding 70% results in an uneducated workforce. Additionally, reservations are usually located far from nearby towns of any size, and the lack of a sufficient number of automobiles or other transportation limits their ability to commute to jobs. Federal social policies encourage welfare over work.

Reservation housing shortages are acute. While 1% of American residents are homeless, 29% of the South Dakota Sioux have no home. Many Indian families live in squalid, overcrowded dwellings, often without sewers, plumbing, or electricity. Only 45% of the homes have a phone, making communication outside the reservation a challenge. Several families are forced to live in a single structure. Houses are poorly built with sub-standard materials and workmanship. Thirty-three percent of their homes, which are located in an environment with harsh climate conditions, are heated by wood. There is little hope for significant new housing, nor is there money to improve existing structures.

As a group, American Indian students are the least successful public school students in the nation. Only 17% of the

high school graduates go on to college, compared to 62% nationally. Students who do graduate are in school only 70% of the time, and only 1% demonstrate above average writing skills. These problems stem from issues such as homelessness, or living in multiple, overcrowded households. Poverty and lack of electricity make studying at night difficult. Lack of transportation and insufficient food present additional challenges to their education. Teacher turnover is higher in reservation schools, and this results in a loss of continuity in the students' education. Also, it is often young and inexperienced non-Indian teachers who instruct the Indian students. There is also great historical distrust towards public schools based upon memories of mandated boarding schools that ripped young Indians from their families and punished them for practicing their Native beliefs and languages. And poverty forces most people to seek employment over education.

Overwhelmed by these statistics, I decided to start by visiting with some of the prominent American Indian community members. They expressed a desire to have college students from the reservation experience the business world during their senior year in college. We established a citywide internship program, and thirty American Indian students were placed in multiple business sites for the summer, including three nursing students in our hospital. They were exposed to the sometimes-mysterious ways of business and gained valuable experience they could put on their résumés. This program gave my nursing team a wonderful opportunity to better understand the culture from which the interns came.

As an outgrowth of this first outreach program, a cultural sensitivity program was established at Sioux Valley Hospital. A

Lakota Spiritual Healer, Wanigi Waci, was brought in to address the hospital staff by Dawn Eagle, who was both a student and professor at the University of South Dakota Native Studies Program. Dawn Eagle had served as a mentor to the American Indian students who participated in the summer internship program and she was also one of Wanigi Waci's Sun Dancers. The Sundance is a spiritual ceremony of sacrifice for the Native People held each summer during the zenith of the sun. It is performed by individuals who have participated in the many beautiful tribal rituals that foster introspection, purification, and compassion as well as a commitment to their Soul Path.

As soon as I saw Wanigi Waci, I felt an instant surge of recognition. I told the COO of the hospital that we must create a dialogue between Mr. Waci and Dr. Brown, the dean of the University School of Medicine. I believed that these two men held a key to making a meaningful start in addressing the health needs of those indigenous to the region. We scheduled a meeting for the following week. When the day of the gathering arrived I felt quite nervous. What if these two men did not connect? What if we could not find a common ground? What if my boss would not agree with the ideas that came forward?

Wanigi Waci, Dr. Brown, the COO, and I gathered awkwardly around the conference table. I opened the meeting by stating the desire of Sioux Valley Hospital was to be more purposeful in addressing the health care needs of the American Indians we were privileged to serve and that we hoped a dialogue might help us understand where to begin.

Wanigi Waci looked at me and said, "JoEllen, thank you for inviting me here. But the truth is that I have been here for a very long time."

I looked at him with embarrassment and replied, "I am sure that you have, Mr. Waci. I apologize that it has taken us so long to acknowledge that fact, but I hope we can now make a good and solid beginning."

Slowly each person put forward their thoughts and feelings about the total disconnect between the cultures.

Finally, the dean expressed his frustration by saying, "Wanigi Waci, I just don't get it. We have written many grants for your people, tried in so many ways to provide services, and yet it just never seems to work out as planned. How does your healing occur?"

Wanigi Waci looked at him and asked, "When someone is in the Intensive Care Unit, what is your job?"

"Why, to make them well, to help them recover." Dr. Brown replied.

"Yes, that is your point of view because you think we are human beings having a spiritual experience," Mr. Waci said. "In our way, we see people as spiritual beings having a human experience."

He went on to explain. "JoEllen, I have been healing within these walls for many years. Do you remember Mr. Phillips?"

Indeed I did remember the young man who had been brought in through the emergency department for massive injuries as a result of a car accident.

"When he was admitted to the hospital his mother called me," Mr. Waci continued. "She said that she knew her son was getting excellent medical care, but she was concerned for his soul, and she asked me to come pray with him."

Wanigi Waci then described how he came to the Intensive Care Unit and asked the nurse for privacy so that they could

pray together. While in prayer the young man's Spirit appeared and informed Mr. Waci that this young man's life purpose was to reunite his family who had been separated by violence and chemical dependency. The Spirit asked Wanigi Waci to call the members of the young man's family and bring them to the bedside. Two days later the family appeared at the door of the ICU.

The nurse recognized Wanigi Waci from the earlier visit and said, "Oh Mr. Waci, thank you for coming. Mr. Phillip's heart is beating a bit more strongly today. I think he may be leaving the unit."

Wanigi Waci agreed with her saying, "Yes, he will be leaving the unit today."

The family members gathered around the young man, prayers were said, and a healing ritual performed. Since we had a code that forbade the burning of sage to smudge the individual, Wanigi Waci placed sacred sage under the body of the patient. Tobacco ties and prayer bundles were strung across the bed, and appropriate chants and prayers were sung. Mr. Waci then sang a Spirit song, and the young man died. It was through the young man's death that the family was healed.

Mr. Waci concluded by telling the dean, "Our job is to honor the life path of each individual and let the Spirit tell us when its work is finished, or if it must return. Our work is to honor the path of Spirit."

Wanigi Waci went on to explain the multiple failures with Western medicine's grant activities on behalf of the reservation. He described how indigenous people are tribal-oriented societies with a collectivist consciousness that dictates that the betterment of the group is paramount to a healthy community and to a healthy individual within the group. Every process,

be it health care or any other, must be developed with the *Tiospaye* (family units) at its core. While there have been many efforts to "fix" or "save" the indigenous peoples, approaches from the mindset of Western society are doomed to fail because there are vast differences between the two races.

Wanigi Waci also noted that to descendents of European societies, it is the individual who is important and, therefore, health care is seen as healing the individual. This individual works with others to be healthy and then forms alliances to establish a community. Descriptive language includes words like "me," "my," and "I." They frequently evaluate their lives on a competitive basis rather than cooperation and integration, while they attempt to build alliances.

In contrast, the indigenous peoples work with all the tribal membership, with Nature and the Cosmos as an integral part of the healing and health process. The individual is not separate from but is a very important part of the whole. An individual can be healthy but if his or her tribal memberships are not healthy then he or she doesn't view their "self" as healthy. When work is done with one tribal member, the potential life impact is group wide. The honor of one is the honor of all. The pain of one is the pain of all. That is why the indigenous peoples say "my People" when they speak.

If any activity in working with indigenous peoples is to be successful, the worldview orientation of the tribal people is essential. The efforts of paternalistic-minded "professionals" have been detrimental to any potential good to the Native tribes and other healers. The indigenous peoples know what to do and how to do it. They need appropriate and adequate tools, resources, and support more than they need "experts"

from another race of people. Finally, Mr. Waci noted that any effort or activity has to be co-created to reflect and honor the sovereignty of all cultures involved.

From that exchange a sense of collegiality and respect between the two healers emerged that continues to this day.

Wanigi Waci was hired by Sioux Valley Hospital to do a cultural sensitivity survey and offer training classes to the staff. We also hired a cultural advisor who spoke the Native language so that Native patients could be understood and better served. Plans were developed for a Native American Healing room where tribal rituals could be carried out, and policies were changed so sage burning and other religious rites could be performed at the bedside. It was a rich time of learning and growing, and a shift in attitudes began. I felt that I was beginning to repay my ancestors' debt.

However, this fulfilling time ended when the CEO retired and new leadership and management were established at the hospital. They put a different agenda before the hospital board of directors in an effort to address the managed care movement sweeping the health care industry. While I have always been supportive of change, the shift in focus away from this rich, multi-cultural work was frustrating because so much groundwork had been done to establish trust. Also, financial indicators for our new program were favorable in other health systems that had taken this approach.

It was especially unsettling since the new administration had openly declared the importance of the "Sioux" in Sioux Falls and Sioux Valley. This acknowledgment was symbolized by decorating the entire corporate suite with Lakota Sioux artifacts and establishing the Medicine Man Conference Room for

medical staff gatherings. To help create this décor, Wanigi Waci had been asked to bring in his sacred objects for a photography session. He asked me if I trusted the new CEO, and I responded that at that point I had no reason to doubt his sincerity. So Mr. Waci brought his drum, sacred pipe, and other ceremonial objects, which later had to be buried for six months as a form of purification.

After all the pictures were taken and the design completed, the space slated for the Native American healing room was turned into a breast feeding room for employees and the cultural program discontinued. At that point I decided to leave the institution.

In my leaving, I took a gift to the CEO. It was a rock that had been found on a glacial summit, a miniature version of an exquisite and massive mountain that fed all major oceans in the world. I mounted it in a wooden case with a glass dome, adding the word "balance" engraved in gold. In parting ways with the new CEO I gave him the gift with sincere intent, telling him that the previous administration had worked out of a model of "people and process" and decisions were made in in contrast to a position of "power and control." I did not pretend to know which model was more appropriate to meet the goals and aspirations of a world moving into managed care, but the use of balance was a sign of wisdom. When using the model of control and power, the counterbalances were the weak and powerless.

I had been delighted when he acknowledged the presence and the role of the Sioux people and felt it was a good balance to the new agenda that was so heavily focused on development of the medical staff. However, I let him know I was disheart-

ened that he discontinued all of those programs while enlarging salaries for key staff positions. I encouraged him to seek balance in his ventures so success in leadership could be his.

Later Wanigi Waci would tell me that I came to Sioux Valley Hospital as a young child, spent fifteen years as a contributing adult, and left the institution as an elder.

I left a position and a community I loved dearly, with nothing specific to turn to. After being home for two weeks, I decided it was time to reconstruct my life patterns. I jumped into the car to find a local dry cleaner, and when I returned home I realized I had not been in a suit since leaving the hospital. I laughed aloud and realized the change may be deeper than I thought!

Out of the blue I received a call from Rochester, New York, from Health Care Resources, a company that hosted four services including home health, community health centers, Equipoise (a holistic healing center featuring sixteen types of non-traditional healing such as Reiki, meditation, homeopathy, and acupuncture), and a research office in Washington, D.C. I was offered the position of executive vice president, and my job was to help integrate Equipoise activates into the Rochester medical community. In this position I learned a great deal about curriculum development, integrative care plans, and funding issues around complementary health care activities.

At that time I was also appointed to the local Home Federal Bank Board of Directors. Curt Lemon, the CEO of the bank, was a very civic-minded leader. He had a passion for empowering community and saw the opportunity to assist South Dakota Indians on reservations, who were then receiv-

ing back-payments from the Federal Government, in establishing their own banking industry. He quickly hired Wanigi Waci to repeat the cultural sensitivity training throughout his bank network, and an economic agenda began to form.

Also at that time was a growing dream to create a healing center committed to indigenous healing practices, cultural education, and research for the Sioux Falls area. Lessons I learned at HealthCare Resources in Rochester became guiding lights to the agenda building back in South Dakota.

Two Communities Meet

My work with Wanigi Waci during those years at Sioux Valley Hospital introduced me to what he called his intentional community located in Vermillion, sixty miles from Sioux Falls. For ten years he had been developing a group of people who could practice the Native traditions while living away from the reservation. All of the elders held doctorate degrees and taught at the University of South Dakota. While a majority of its members were American Indians, the community also included people of many races, including Caucasians who felt more at home in this environment than in Western ways of worship.

Wanigi Waci was the cultural advisor for the indigenous college students at the university. He had great compassion for the confusion and displacement many felt as they stepped outside of their reservation's boundaries. Even reading a textbook, for example, presented a challenge to many of his students. He taught the students to begin a text by reading the last chapter, which summarizes the book as a whole and explains how everything in the book is interconnected. Then, the stu-

dents could start at the beginning of the textbook, which was written in a linear fashion and reflective of the Western way of thinking and writing, and fully understand the knowledge presented in the book.

The Western way puts strong emphasis on the individual and the need to be highly competitive. These concepts were also foreign to young people raised with an emphasis on *Tiospaye* (family) and cooperation. Many students could not resolve these discrepancies, and those problems, compounded with inferior math, science, and writing skills, and loneliness for family inevitably discouraged them enough to return to reservation life.

Wanigi Waci's primary focus was on enhancing self-esteem, promoting cross-cultural understanding, and teaching life skills while providing a community that upheld their sacred values. He personally set up micro-loans so that students could begin to create a personal credit rating. He designed a chemical dependency treatment program based on Native beliefs, and offered an annual gathering for Wounded Warriors. Working in conjunction with a colleague and elder, Duane Gray, the two created the Heart Room curriculum for the many young children on the reservation who were victims of incest and child abuse. This program provided support for such young children through their third grade school year. The youngsters were held by Native grandmothers who told stories and sung to them in their Native language. By using coloring picture books and play therapy, children were taught how to care for a chemically dependent parent. In short, this program offered survival skills to youngsters faced with family challenges of untold magnitude.

When I started working with Wanigi Waci more closely he asked, "Jo, what is your definition of success?"

I looked at him, startled, and replied, "What are you asking?"

Wanigi Waci responded with a deep sadness in his eyes. "My goal is to save just five children. If we create an off-reservation space that is safe, they will come and experience what being safe feels like. It will give them hope as well as the will to live to their full potential. Five will be enough to move our people into another generation in a healthier manner. If you are looking for numbers bigger than that, do not work with me."

In that moment I thought of the Mennonite saying about the power of "one small remnant." Our people told the story of how an entire wicked city was saved because God saw that one small group of people within the city remained true to their beliefs. It was a powerful story about the power of small numbers, and in that context I understood what he meant. I signed on.

Wanigi Waci taught the traditional ways to all who came to the community and reinstated various clans within the tribe, such as Pipe Carriers (who cared for the sacred pipe, their primary vehicle for offering prayers) and Sun Dancers (who performed a sacrificial ritual to offer healing to the People). A generous local farmer gifted him with a small piece of land where the sacred ceremonies could be held. On this ground were two *Inipi* sweat lodges and a hill for the Vision Quest Ceremony. Many sacred rituals and healing ceremonies were performed in this beautiful prairie landscape. American Indians who had left the reservation could find a place to worship that honored their traditional roots and culture. It was a sacred space in which to refresh their souls.

As I got to know the Sioux community better, I was invited to share in some of the ceremonies and ritual. Being with them felt like coming home. There was much that I did not understand and yet it was all very familiar. Their ancestral roots resonated with my colonized roots, and I arranged a trip for members of Wase Wakpa community to visit one of the local Hutterite-Mennonite colonies nestled along the James River.

We started our colony tour in the meetinghouse, a stark building with benches and a preacher's platform. Nothing is ever placed on the walls for the religious tradition forbids any graven images. No musical instruments except for strings are allowed. All is "plain and simple," rustic and beautiful, wrapped in a deep sense of quiet dignity and peace.

The bearded preacher greeted the group in his traditional black suit, his head covered with a hat. He asked Wanigi Waci, "Why did you come here? What is it that you want?"

"I am here to get to know you and to see how you have set up a way of life that sustains your people," Mr. Waci replied. "My people have been forced onto the reservation. It is a holocaust that continues. I would like to understand you, and to learn from you how to set up schools, living facilities, and farming activities to support my People in their traditional ways."

We were invited to lunch in the large dining room, feasting on fresh baked bread and an ample German meal. After touring the facilities we reconvened in the meetinghouse.

By now the two spiritual leaders had become fast friends and words describing sacredly held dreams flew between them. As each was speaking English as a second language, they would grope frequently for words that both could understand. Many concerns were shared and validated, new ideas

abounding. They explored topics such as education, economics, maintaining tradition while embracing change, the care and nurturance of children, and ways to maintain the soul of a community. When they finished their discussion the young women of the colony began to sing in sweet and clear a cappella many hymns that resonated with my upbringing. I found myself joining in the beautiful harmony of "*Gott Ist Die Liebe.*" It took me back to my childhood in Grandmother's kitchen, and tears filled my eyes. When they finished singing a deep silence filled the room.

Then Wanigi Waci and his tribe brought out a drum and filled the room with chants and song. It was a loud, throbbing sound in contrast to the sweet soft harmony of the young girls. Tribal elders presented the preacher with a star quilt, the sacred symbol of their origins from the Milky Way. The Lakota believe that they have come to earth via the Milky Way, and the star is a symbol of their creation story. They also believe there is a similar and parallel universe in our galaxy on the other side of earth that is made of light rather than matter. The elders then offered prayers of gratitude and blessing for this culture so different from their own.

As each group shared their songs, stories and prayers, I became aware of something amazing: At core the Mennonite and Sioux beliefs were essentially the same. After we had all exchanged gifts, a sacred hush wrapped around the group.

Greatly moved, the preacher said, "God speaks in many languages. Thank you for the gift. We will hang the quilt on our wall."

This was the highest honor my culture could accord.

We exchanged emotional good-byes, all of us aware that

our two cultures had become friends. Perhaps it stirred in all of us a memory of the relationship our two cultures had shared so many years before.

On the way home Wanigi Waci was off in another space. After a moment of silence I asked, "So, Wanigi Waci, where did you go just now?"

He looked at me deeply and said, "Jo, this is the first time in my life that I have been in the presence of white people who do not have a history of slaughtering my people. I have never known such safety."

My Enlarging and Merging Consciousness

Shortly after I started working with Wanigi Waci at Sioux Valley Hospital, my beloved grandmother became ill with cancer. I tried to get home to spend time with her, but it was never enough. She had a tumor in her throat, making talking and drinking difficult. Her strength was waning so I ordered "meals on wheels" to be delivered anonymously by the local café. After the second week the café's cook called me in desperation and pleaded with me to discontinue the service.

When I asked her why she replied, "Your grandmother is a dear soul but she is so stubborn. She gets upset each time we come by. She tells us that she has plenty and that we should give the food to the poor and starving people in town."

That was the end of my "care taking" effort on her behalf.

Finally her strength was gone; it was time to move her to the local nursing home for hospice care. The night before she moved I arrived at her home at sundown. We stood together on her back porch, looking out over the lawn and garden that had

hosted so many family gatherings and childhood adventures. I put my arm around her and asked if she was ready to go.

She looked at me through thick eyeglasses that made her eyes look wide and deep and said, "Joey, I will be just fine. Last night I stood here looking at my million-dollar tree where you all climbed and played. Suddenly a cloud came up in the sky. It kept coming closer and closer until it almost touched the house. As I looked at it I could see the eye of God. He is with me, looking after me. Everything will be good."

True to her style, she never complained about anything, but always found something positive and good. That was the last conversation we shared in her home.

She deteriorated quickly in the nursing home, and within several months she needed to be moved to the local hospital for palliative care. As her death became imminent, I tried desperately to get home in time to say goodbye, but work at Sioux Valley Hospital kept me late into the evening. I arrived at the nursing home long after visiting hours and quietly slipped into her room.

Her thick breathing changed abruptly and she said, "Joey, is that you? I knew you would come."

"Grandma, how are you doing?" I asked her.

"Oh" she said, "I am so cold."

In that moment I had a flashback to the story she told often and with great heartbreak. It was the only time I ever saw my grandmother cry. She would recall the moment of her mother's death. Grandmother was five when her mother gave birth to a brother. The following day the house filled with people, and my grandmother felt something was terribly wrong.

Suddenly she was taken into the bedroom where her mother said "Daughter, come here for I want to hold you."

Grandmother recalled how bad the smells were in the room, how gray her mother looked. She became so frightened that she ran out of the room instead of into her mother's arms. Shortly after that she was told that her mother had died.

With tears filling her eyes she said to me, "I often wonder if I had gone to her and held her, would she have loved me enough to stay?"

I looked at this emaciated woman lying in bed and remembered the remorse she held around her mother's death. I quickly lay down beside her, wrapped my arms around her and held her close, telling her one more time how deeply I loved her and how grateful I was for all the wonderful things she taught me. We had one last chance to share things and bring them to a good place.

Then I asked her, "Grandma, when you get to this place in life and look back, what will have been the best time for you?"

I felt her body stiffen with impatience and she snorted, "Well now!"

I was incredulous. "Now?" I asked in bewilderment. She weighed less than eighty pounds, had lost a husband, son, and grandson, and was living in one small room in a nursing home. "Grandma, I'm sorry, but I just don't understand."

Gently she replied, "Just listen. Can't you hear it?" We lay there side by side listening to a silence so deep and profound that it pulsed in my ears.

"That's God you hear. When you get here, where I am now, the best part is that you will just *know*. Now I am ready to cross the Jordan and go home."

In that moment I realized that wisdom is the benediction on a life well lived.

"Go home, Grandma," I said, "and Godspeed on your journey." Those were our parting words.

The next day she was moved to the hospital and I flew off to a conference in New York for a speaking engagement. The following morning I got up early and walked along the ocean, watching the waves breaking on the shore.

Suddenly a bird flew by very low, catching my attention. I was startled to hear my voice say, "Go to the shore, Grandma, go to the shore." I looked down at my watch and saw it was 10:20. I knew that she had passed away. I ran to a nearby pay phone to call home. Breathless, I asked my mother when Grandma died.

She was frustrated and queried, "Who told you? I told people not to tell you till you got home."

I replied, "It's okay, Mom. Grandma told me."

The day of her funeral was particularly beautiful. The sun was bright and the sky so clear. As I drove out of the yard towards church I saw a large hawk sitting on the telephone pole at the end of the driveway. As I moved down the road it flew along side the car, accompanying me most of the six miles to church. I was thrilled and my heart felt lighter watching the hawk dip and soar.

At the funeral I had the great honor of helping carry Grandmother's casket. Gently we laid her to rest. As she was lowered into the ground, I saw a large hawk take flight and circle over her grave. Again I had that sense of peace and joy as I watched it soar. After the funeral I stayed at the church to help clean up and took the remaining sandwiches and cake back to the nursing home that gave her sanctuary for her last days. As I started to drive back to the farm, a large hawk again accompanied my ride. Three times in one day! I was amazed and con-

fused, but quickly dismissed the event as simple coincidence.

During the following three weeks, each day as I left the house for the drive to Sioux Falls a hawk would appear and dart about my car for miles at a stretch. Finally, I could contain my curiosity no longer. My father had told me about Native beliefs regarding animal totems. I took all my courage and went to the Department of Native American Studies at the local college to visit with their cultural advisor.

He told me that animal totems carry a certain spirit, an energy. When people die, they often will visit those they love disguised as a totem. If a totem comes into your life you will "feel" its presence very distinctly. You are to observe it closely and it will guide your path.

I said, "So what does a hawk represent?"

"Oh!" he replied. "A hawk flies high above the turbulence, using it as energy to coast on. It is the symbol of leadership and the spirit of the Grandmother."

My heart quickened.

Several months later I was invited to New Zealand on a consulting assignment. I quickly became a friend of an exceptional young Maori nurse named Tanya. She very generously took me around the city of Auckland and shared stories of her ancestry.

Suddenly she said, "You've just got to meet Mum." And I found myself being ushered into her mother's home.

As my eyes adjusted to the darkness I was facing a large woman with deep piercing eyes, sitting in an overstuffed chair.

She stared at me for some time and then said, "I *KNOW* you." I was most uncomfortable and certain that I had misunderstood.

I replied, "Nice to meet you, too."

Her mother, Olive, and I shared a few trivial exchanges and Tanya took me back to the hospital. The meeting with her mother was very unsettling and haunted my memory for weeks after I left. Eventually I forgot our meeting completely.

Several months after I returned to the United States, Tanya called and asked if she could come and spend some time with the nursing staff at Sioux Valley Hospital and me. I was over-joyed and found myself as her hostess for a month. During that time we became fast friends and my world was once again enlarged. I also discovered the Maori culture was similar to the Lakota Sioux, with death rates and health challenges similar to Wanigi Waci's people.

Spring arrived once again and I was invited back to New Zealand. While there, Tanya's family invited me to a gathering where they adopted me as a member of their family. A wonder-ful celebration ended well after midnight.

When the final guests had left I was moving towards the bedroom when Tanya's mother sat down and said, "And now we talk!"

Obediently I slid back into a chair directly across from this powerful woman.

She began, "The first time you walked through the door I saw the aura of your grandmother. You are your grandmother's child."

I could hardly believe my ears, what did she mean? The hawk continued to show up during times of difficulty or delight, and then I would not see it for weeks. I was so con-fused; nothing seemed to be as it appeared.

Olive went on to explain a Maori belief. "We all come to this world for soul growth," she said. "Prior to our coming we

make a commitment to a soul group of twenty to thirty people. At the appropriate time in our life journey, they show up. We recognize them at a subtle level and each contributes to the other's advancement. They may be a most powerful friend, ally, or even a detractor. Each plays a role in our growth motivated by love coming from the level of soul. Within each family of origin there are certain themes and challenges that must be overcome if the whole family is to prosper and advance. These culturally bound shadows are difficult to transcend.

"Each generation has a chance to break the bonds, and if they do not, the next generation's job is more difficult. So as one elder is about to leave, the one who agreed to continue the work is given their energy. The elder then moves to the other side of the veil and continues to guide and support the soul who is working to liberate the family."

She went on to explain that when the wisdom keepers leave this life, they choose someone to receive their cumulative lifetime knowledge. I had been with her extended family totaling nineteen people all evening.

She asked me, "Which of the grandchildren is my protégée?"

Without any hesitation I said, "The four-year-old girl."

"You are right!" she chortled.

I realized that I could see the connection between them, an extra sensitivity and strength the youngster displayed above that of her older siblings. Amazed, I suddenly had a new perspective on so many unexplained things in my life—it was a moment that redefined boundaries and possibilities forever. From halfway around the world I had come to see my Self for the first time.

A Journey of Birth and Manifestation

Germany was a magical time for Kristi, a time of refining her language skills and of going deeply into our ancestors' culture. Upon her return to the United States, she and Eugene were married. It was an international celebration with friends from across the continent and from Europe coming together to wish the couple well. As I listened to people greet Kristi and share stories about their time spent together, I got another perspective on who she is and what she is doing in the world. It was a very special time of celebration.

After several years in their respective careers, Kristi and Eugene decided it was time to start a family. The large urban

cities in which they had lived were exciting and filled with opportunities. However, they also held challenges that were not conducive to the life of a child, at least as they had known it growing up in South Dakota and Iowa. They moved back to the Midwest.

I was overjoyed when they chose Sioux Falls. Suddenly my daughter was back in close proximity. We would once again be able to pick up a phone, meet for lunch, and share the smallest details of life.

The Birth of Ethan Lee

Kristi became pregnant shortly after their return. Dennis and I were overjoyed with the prospect of a grandchild who would live nearby, and we began to prepare for this shift in our own life. When Chip and his beautiful wife, Kathleen, gave birth to Kyle, now four, and Kahler, two, we had to incorporate the concept of "grandparent" into our self-image. We did so with much joking and great delight as we both had powerful experiences with our own grandparents. Chip was enjoying a successful career as a civil engineer for Halaburtin Construction, living in various parts of the United States. Unfortunately, we were only privileged to be with the boys during holidays and special events. Since the Welch family lived in the neighborhood, we purchased a small crib so we could host the newest family member and offer respite to tired parents. Only on rare occasions would I let my mind remember the pattern around childbirth that had plagued the mothers in our family for generations.

The first six months of Kristi's pregnancy went well. She felt good, looked wonderful, and was totally consumed in

plans for the baby, the nursery, and life as a mother. In the beginning of the sixth month she started to have some problems. I had left Sioux Valley Hospital just as Kristi became pregnant and was doing consulting work when she started to develop prenatal complications. Within a few weeks she was on total bed rest. I took her into our home and cared for her during the week, juggling my client assignments to fit in with her husband's schedule so we could keep both of our business careers afloat. On the weekends she would always return to her home for time with Eugene. It was difficult to watch her discomfort and growing apprehension without projecting on her some of my own. Still the intimacy we shared during those moments together was precious. Ironically, we would never have had them if she had remained healthy.

After several weeks had passed she began to experience contractions. She was given a series of medications to inhibit true labor while keeping her blood pressure within a safe range. She reached the thirty-sixth week of pregnancy and the date to induce labor was set.

The final meal we shared was a celebration, a rite of passage. I had carefully prepared her favorite foods, given her a crystal angel to watch over her, and packed her bag for the hospital. When Eugene drove up to the house with a sense of keen anticipation, we all shared in the fellowship of our meal, and then Eugene escorted Kristi to the 9:00 P.M. admission.

After he left the hospital at midnight, Kristi called to tell me that the delivery nurse providing her care was the same one who had delivered her so many years earlier. I was invited to Sioux Valley Hospital to spend time with the two of them. Her nurse and I had wonderful reunion as we sat with Kristi

telling stories of her own birth while preparing Kristi for the upcoming events. All through the night Kristi labored, but no baby was born. When Eugene returned later that night, I went home to get some badly needed sleep.

The night nurse went home and a second nurse came in to provide care for the day. By now Kristi was having frequent and hard contractions, and her discomfort grew. At noon I stopped in to see her. The nurse told me that the head was crowning, she could feel the baby's skull at the outlet of the birth canal. It would not be long until the baby was born. I had been present for so many days throughout the whole pregnancy that I wanted to give Kristi and Eugene some privacy. When they encouraged me to attend a bank board meeting several blocks from the hospital, I agreed.

An hour later I was sitting at the boardroom table, when suddenly I was startled by this horrific sense of dread sweeping through my body. I hurriedly excused myself from the meeting and rushed to the hospital. As I was running down the hallway towards her room, Eugene stepped out of the operating room dressed in green surgical scrubs. He was crying.

Startled to see me, he asked, "Who called you? I was just going to have someone find you. Kristi is in trouble."

I told him, "Kristi called me. Please go be with her Eugene, and keep me informed as you can."

Those moments of waiting in the hallway seemed like hours. I kept thinking to myself, "People don't die in childbirth anymore. Oh, please, God, spare her life." And then all I could say was, "Thank you, thank you for sparing her life." I would not let my mind stray into any other thought. After a moment that was timeless the physician appeared. He told me that the

baby had become lodged in Kristi's birth canal. The head never was engaged; the nurse had misdiagnosed the status of her labor. Suddenly Kristi's physical condition had crashed from all the difficulties of her pregnancy prior to delivery. An attempted forceps delivery was not successful, and they had to perform an emergency Caesarian-section. Her fragile status had collapsed her veins forcing them to make repeated attempts at starting an IV. Our family history of malignant hypothermia, a lethal reaction to anesthesia, required a spinal anesthetic. Because she was so compromised it took five attempts for the anesthetist to successfully prepare Kristi for the surgery. By then her vital signs were very fragile; she recalled being outside her body and witnessing the procedure while floating about in the room.

After her delivery and recovery Kristi was moved back into her room. I was shocked by what I saw. My beautiful daughter's face was so swollen from the medications, fluids, and struggle that I hardly recognized her. She was shaking so violently that her bed was quaking. After all of her surgical caregivers had left, I moved to her bedside and simply held her hand, stroking her hair. She looked at me as big tears slid down her cheeks. She would tell me later that the only thing she could see was the little ruby glass slipper pin I was wearing that had been given to me during a particularly difficult time in my life. When she saw the pin she knew it was me, and she said the symbol of the pin gave her the strength to hold on.

After her condition stabilized, they brought in beautiful little Ethan, weighing slightly over six pounds. This exquisite child, also swollen from his prolonged time in the birth canal,

was gently laid beside his mother. Eugene was both exhausted and elated. The ordeal was over.

Watching the family bond was a moment I will never forget. They asked me if I would like to hold the baby. Taking this child into my arms and looking at the extension of my lineage produced an emotion like none I had ever known. Ethan had some of Kristi's characteristics, including the way he held his hand with the little finger extended in the same way his mother had so many years earlier.

When the nurse came in to check on the family, she took one look at Ethan and suggested he go back to the nursery. Suddenly I was called by the nurses—my friends and colleagues for so many years at Sioux Valley Hospital—and told to come to the nursery. Once inside they showed me how blue he was, how retracted his breathing had become, and he was immediately rushed into the Intensive Care Nursery.

This began a series of tests and activities that uncovered a serious infection from his prolonged time in the birth canal. For ten days the doctor told Kristi and Eugene that Ethan was in a critical condition and that he could not guarantee that Ethan would live. After Kristi recovered from the prolonged labor, attempted forceps delivery, and C-section, she was released from the hospital. Each day I would watch her go to the Intensive Care Nursery and support baby Ethan who was struggling for his life.

On the sixth day I stepped off the elevator and there in the waiting room sat Wanigi Waci.

"Hello, Jo," he greeted me.

Surprised, I said, "Oh, Wanigi Waci. What are you doing here?"

"I am here to visit my nephew," was his gentle response.

"I am so sorry, Wanigi Waci. Do you have a relative here too?"

"Yes," he said smiling. "His name is Ethan."

I had not notified him about Kristi and the baby, but he had sensed it anyway in that deep way of knowing that was becoming so familiar to me.

Together we went into the Intensive Care Nursery. Kristi was inside holding Ethan and singing to him. Wanigi Waci had brought a small medicine bag filled with sage, herbs, and other healing remedies. He performed a healing ritual for Ethan as he had for so many others of his tribal family. The ceremony was the one we had developed protocols for when the Cultural Sensitivity program was established so many years earlier. It was very comforting to me to participate in this ritual that had brought comfort and strength to so many others. When he was finished, Wanigi Waci told us that Ethan would recover, and that all would be well. We walked out of the nursery together, with a grateful Kristi watching from the picture window.

As we left the hospital he said, "Ethan is a brave soul, a child of the water clan. He had a choice to make and he chose to come and be part of your family. He had a chance to return to the Spirit world, but he kept his commitment to Kristi and Eugene."

Wanigi Waci proceeded to explain how spirits select their parents before birth. Sometimes as the time of birth approaches, if they can see the road will be hard or other phenomenon exist that they were unaware of, they can change their minds. He told me that Ethan holds a warrior spirit, and he is of a strong constitution. He made a second conscious decision to join the family, and he would be good medicine for the Welch family.

For the next six months Ethan was in and out of the hospital with multiple respiratory complications. His little hands were so scarred by IV's that they had to use scalp veins to give him medication. While he was suffering physically he was bathed in total and unconditional love from his parents and extended family.

Over time, mother and child were restored to good health, and the incident became a part of our history that blessedly now was in the past. The Welch family settled into a rich and robust life of working parents and day care intertwined with magical evenings and weekends with our entire extended family.

I suddenly realized that I was now fifty and feeling quite frisky. The children were raised and established, my husband was thriving in his farming career, and for the first time I had no real responsibilities. I began to reflect on the things that meant most to me and what issues most deeply touched my heart.

The managed care movement was forcing patients out of the hospital at an unprecedented rate, and I often worried about what happened to them once they returned to the community. I had grown increasingly frustrated that so much time and energy was spent on acute care, without a balancing focus on health and wellness. Repeatedly I watched families face bankruptcy because a health crisis had drained their resources while, at the same time, it had left them with a chronic illness that marginalized their life. Working with Wanigi Waci and other colleagues who were practicing homeopathy and organic nutrition, I was being exposed to health-promoting models that preceded primary care. I also saw that in the current managed care environment, there would be little room for those illness

prevention services because the medical model was so focused on illness management.

I was in the midst of this period of reflection when my phone rang. It was a colleague in Texas who was looking for someone to go to Rochester, New York, for a year to help strengthen the nursing practice of HealthCare Resources, a company that focused on home health, community health, and holistic healing practices. Astounded, I looked into the company and found it contained many of the core elements that interested me most. So after another deep soul-searching conversation with Dennis, we decided that I would go to New York for a one-year sabbatical to learn about small businesses focused on health promotion and prevention.

Having spent my entire life working for large organizations like Sioux Valley Hospital, I wanted to discover new and untraditional models for delivering care, especially to those people existing outside of hospitals so burdened with debt. I had hoped to learn strategies that could help develop health services for the underserved in South Dakota, such as the Sioux and the uninsured. I accepted the position of executive vice president of Health Care Resources; a small business, owned and operated by a savvy businesswoman who had won the Entrepreneur of the Year Award from President Ronald Reagan. From her I would learn what tenacity means, and how difficult it is for a small business to integrate its services with large health care providers.

One of my assignments was combining holistic care with primary care in the medical community. We sponsored dialogue sessions at Equipoise, the holistic healing center that was part of HCR. This particular dialog was limited because

we featured only the complimentary therapies that had been approved by the National Institute for Health as reimbursable by insurance.

On one particular evening, a well-known neuroscientist and an acupuncturist (both medical doctors) shared the philosophy and science behind their respective healing practices. The neuroscientist gave a lengthy and illustrative talk on pain management utilizing the best of modern science. The acupuncturist then proceeded to discuss chronic pain management using the meridians and pressure points of the body. One service cost thousands of dollars and had a high recidivism rate, while the other was inexpensive and could be performed by the patients themselves.

To demonstrate the value of acupuncture a male participant with a headache was invited to the front of the room. The quick relief the volunteer received from acupressure startled the renowned neuroscientist. Since both practitioners were medical doctors, the debate was held on multiple levels, each professional matching the other for wit and wisdom. After a delightful evening, a respect for both types of practice was established, allowing the real issue to surface: Many people utilize both types of pain management, but their practitioners do not know this because the patient keeps it a secret, fearing judgment from both professionals. The answer seemed obvious to us: We needed to create a shared medical record, managed by the patient, which would go between various practitioners to enhance communication and collaboration. As a result of that dialog we generated some very rich studies around shared services to demonstrate the efficacy of this blended approach to treatment and healing.

My favorite experience happened during the time I spent with the African-American and Hispanic communities within Rochester. As I spent more time in their local health care centers, the people became more comfortable in sharing their stories with me. One local neighborhood had finally gotten a grocery store to open after five years of lobbying. Many merchants had made the assumption that poor people would not pay their bills, so they didn't want to do business with them. However, once the grocery store was in business, there was actually less payment delinquency in this branch than any of their other stores in other parts of town. And once people had access to fresh fruits and vegetables, instead of junk food from the corner gas station, their health notably improved.

The churches were the glue for a large African-American community served by one of our centers. We were offering free home health aide training to church members who would in turn provide services to their community.

One day one of the center staff members, Joseah, asked, "Aren't you going to tell us what to do?"

Startled, I said, "I'm sorry, Joseah, but I don't understand what you are asking."

"We always get do-gooder professionals in here telling us how to run things," he replied. "Last year a gal came in with a grant for teenage pregnancy. The first thing she did was hang a big sign for 'Free Prenatal Counseling.' I looked at her and laughed when she walked out because you know what? We don't call it pregnancy around here. And no gal is going to talk to some white stranger about it either."

I asked Joseah what he would do if it were left up to him.

"First thing I'd do is put on the coffee pot, and just hang

out waiting for folks to show up. You have to start with the relationship. If you haven't got that, nothing's gonna happen. Once you pour them a cup of coffee, you ask them about the family…'how's things?' They start to tell you about their kin, and before you know it, the talk turns to themselves. And if we just had half the money you folks puts into programs you built *for us* instead of *with us*, we would have all the cash we need to get folks the food and transportation they need to get the job done."

Repeatedly people told me that working with health professionals was demeaning because we came in with solutions to problems we did not understand. If we professionals would only listen to them and respect their own wisdom, then the caring and the curing we provided would reflect the needs of those cultures. Once again, the wisdom demonstrated by my own "uneducated" grandmother flashed in my mind, and I was humbled by the profound understanding and insight possessed by individuals throughout society.

Having spent my entire life in South Dakota, the time in New York was a radical departure from my rural view of the world. I learned much about myself, about others, and about the common issues and themes that are universal to society. We were nine months into my sabbatical, just finishing a grant proposal and several contracts for care, when I received two phone calls that made the distance from South Dakota seem too far.

My mother called one evening and asked, "Jo, when will you be coming back?"

This was very much out of character for her. Alarmed, I quickly returned home to discover that her health was deterio-

rating rapidly. She had lost sensation in her feet and was walking with the support of a cane and walker. She had also become uncharacteristically despondent. It was apparent that this would be her last winter living independently in her home of fifty-four years.

A second call came just as I was leaving for South Dakota. It was Kristi, announcing that she was pregnant again. She had been to the best perinatologist in the city for a complete exam, and he had assured her that what had occurred last time was simply part of being a first-time mom. He saw no pre-existing conditions that would cause her problems again and encouraged her and Eugene to follow through with their desire for another child.

After my trip to South Dakota, I returned to New York and ended my sabbatical. Going back to South Dakota with two special women in my life facing health status changes was most distressing. Upon returning home I tried to discern how best to support both my mother and my daughter while maintaining their autonomy and optimal health. Mom endured a series of treatments with orthopedic, neurology, acupuncture, and chiropractic specialists to address the growing nerve damage in her feet induced by years of diabetes. We provided her with a whirlpool and massager for foot care. She spent the rest of the year maintaining a fulfilling civic and social life, despite having to walk slowly with a cane and to back down stairs. Of greatest concern to me was the fact that her energy was fading fast. She began to sort through her things, gifting the grandchildren and significant others with treasures by which to be remembered. A ritual of closure, over which I was powerless, was being enacted before my very eyes.

The Birth of Joshua Joseph

Once again Kristi started her pregnancy with no problems, but at six months complications arose. This time her pregnancy was more complex; with Ethan only 18 months old, getting enough bed rest was a real challenge. Dennis and I took Kristi back into our Sioux Falls condominium, a peaceful home settled within a valley of tall and gnarled oak trees. During the evening Eugene brought Ethan to visit her. She could not return home for the weekends because Ethan could not understand why his mother had to stay in bed rather than pick him up or play with him.

During her seventh month Kristi's condition began to deteriorate rapidly. She was receiving traditional prenatal care and the perinatologist treated her symptoms with bed rest and antihypertensive medications. He was focusing on keeping the baby intact in his mother's womb for as long as possible. But she continued moving into an endocrine system slide with the emergence of diabetes, hypertension, toxemia, preeclampsia and contractions that were palpable. Being a nurse is not always a positive quality because one quickly projects events towards a "worst case scenario." I knew things were compounding; no treatment seemed to reverse the tide of events.

One evening we had just returned from the medical clinic that had confirmed that the hypertension and contractions were unchanged and dangerously high. I had just helped Kristi back to bed and was standing in the kitchen praying for a miracle when the phone rang. It was Wanigi Waci saying, "Jo, Kristi is very ill. I will come and do a healing ceremony for her."

Within hours Wanigi Waci was in our condo basement with his drum, herbs, and other healing remedies, to minister to both Kristi and me. His sense of humor is profound, and it is a gift he uses to bring perspective to the moment. Needing a container to hold the lighted sage for the sacred smudging ceremony, he disappeared into the garage, only to return with a paint roller pan. That stained and bent pan became the central focal point of a healing ceremony that included smudging, spirit songs, prayers, and healing herbs. In examining Kristi's vital signs after this beautiful and loving ceremony, I discovered that the strong contractions has stopped, her blood pressure was lowered, and her condition had finally stabilized and would remain there for the first time in two months.

Within two weeks, though, both she and the baby took a turn for the worse. The phone rang. Once again it was Wanigi Waci who was calling because he sensed Kristi's fragile state.

"My community will offer a healing ceremony for your family. But first you must make 405 prayer ties for your daughter. For four nights we will offer Inipi Ceremony on our ceremonial grounds, and then you must give something back to the Creator."

This gentle healer's sensitivity to the plight of a family sixty miles away, with no blood relation to him, moved my soul. The generosity of his offer, and the support of a community who had never met my daughter, were equally profound.

A prayer tie is a one-by-one inch square of cloth filled with a pinch of tobacco that has been passed through the cleansing smoke of sage smoldering in an abalone shell. The tobacco offering is a symbol of the prayer being expressed. The shell is a metaphor for the human spirit; rough in its exterior manifes-

tation in the human, material world, while smooth and beautiful in the inside, like our innermost spiritual realm. I was to say a prayer as I prepared each of the 405 prayer ties.

I sat at my kitchen table and made 101 black ties, 101 red ties, 101 yellow ties, 102 white ties, and six spirit flags of black, red, yellow, white, blue and green. As I filled one tie I would pray for the health of Kristi, the baby, and all the People. The next tie would find me singing songs and saying Bible passages in German, my original language. Making the ties, connecting them all into a seamless whole, was like praying a rosary; a rhythm and tempo guided my thoughts. I felt my grandmother's presence especially close to me during that time. It took most of the night to complete the task. By dawn of the next day I was ready for the ceremony. I carefully wrapped the ties around pieces of tree branch that had been blessed, placed it carefully in the car, and drove to the Wasa Wapka ceremonial grounds in Vermillion.

The Inipi sweat lodges used for this prayer-full ritual were housed on the tribe's ceremonial grounds. A pile of stones, which hold the memory of all things, was heated in a large round pit for several hours before the ceremony began. The prayer ties and flags were placed on an altar and offered to the Creator. One by one, and on our knees as a gesture of humility, we entered the lodge, a symbol of the womb of the great Earth Mother. As each person entered he or she called out a greeting, *"Mitakuye Oyasin"* ("All my relatives"), while moving clockwise around the fire pit. When we were all seated, the heated rocks were brought in. Each rock represented a different direction in the medicine wheel. Pieces of sage and cedar were spread on the rocks, filling the lodge with their pungent aroma,

like incense in a cathedral. The prayer ties—representing the prayers of the People—were brought in along with a bucket of water. Then the door was sealed.

In the total darkness all that is visible was the red glow of the rocks. Water was ladled onto the rocks, making them hiss and release wafts of steam. This steam cleansed our bodies while our prayers cleansed our souls. For four rounds the people sang and prayed, with each round focusing on a specific aspect of spiritual being. The red pipestone pipe, which had been consecrated by the Spiritual Leader, Wanigi Waci, was passed around and each person prayed for something specific in their life and the lives of all People.

All ceremonies move between the individual and the collective, starting and ending with the focus on community. The Sioux believe that smoke from the pipe carries prayers heavenward. Between each round the door is opened and water is given to each participant.

The cool rush of air that entered the lodge that first night was such a welcomed guest. The cycles of total darkness and light, intense heat and cool air, prayer and song, drumming and silence, made me lose track of time. I felt the love and intentions of all the people who participated in the ceremony.

On the second night a beautiful little three-year-old Native American child, Tessia, with long black hair and deep brown eyes, came to pray for Kristi's baby. She sat between her mother and myself for all four rounds of this night's ceremony. I felt a sudden rush of insight that such love and sacrifice given for someone she, and many of the others, had never even met had profound healing power. The deep sense of community experienced over the four days of ceremony made

me acutely aware of how seldom this level of commitment for another is present in many of our contemporary Western relationships.

After the ceremony Kristi and the baby both stabilized and remained in that state until her delivery. This was a most confounding moment for a nurse and scientist like myself who had spent her entire life studying and supporting the Western medical model of healing, especially since the Western way of healing was unable to sway the tide of events affecting my daughter and grandchild.

I had always looked at illness through the lens of science in a cause-effect way. However, upon closer examination I realized that as a nurse, I always approached my patients by establishing a therapeutic relationship. From that starting point the various healing therapies were used as tools to support a process that in essence already resided within the patients themselves. I saw a parade of faces and places from my rich career as I recalled incident after incident where the same treatment that worked for one person did absolutely nothing for another. I could clearly remember the individuals who got better because of their deep faith in their own ability to recover, and those patients who declared the situation hopeless and gave up in despair.

When I could, I helped my mother and my daughter go from one doctor's visit to another, all of us wishing for a word of encouragement or a glimmer of hope that their conditions would improve. I watched them return with a prescription, a pill, a referral, or a treatment regimen to try. It was then that I fully understood what the New York wisdom keeper, Joseah, was saying when he spoke about the sterile and professional

stance taken by many who dispense medicine without dispensing a belief in the power of the individual to heal themselves.

I had reached an ontological crisis: The comfortable and well-proven scientific model of Western healing was not attaining outcomes as profound as those obtained through the prayers and love of the Sioux community. When the patient is your daughter, the results are in your face. From this day forward I would continue to honor Western medicine for the good things it could offer, but would acknowledge that there was another whole world of healing that goes beyond the mechanical approach to healing the body. It is a healing model that ended up touching the soul of my entire family.

After the Inipi sweat lodge ceremony, Wanigi Waci instructed me that each day until delivery I was to make seventy-five prayer ties and hang them in the trees outside the condominium, close to the Earth Mother. On occasion business travel forced me to make the ties in my hotel room, hanging them in the surrounding trees when I returned home.

Prior to the turn of events in Kristi's pregnancy, I had decided to change career focus. Upon leaving Fielding I began a dialogue with its president, Dr. Donald MacIntyre, telling him of the great need for an international nursing doctorate that would allow nurses to study in their own country while sharing learning experiences with colleagues from other parts of the globe.

While I was a Fielding student I interviewed a young doctorate of nursing student from an Asian country who was attending a wonderful American university. She told of leaving her young son and husband and her entire extended family for a three-year course of study. It was a very meaningful and exciting time for her. However, she said that much of what she

was learning had no relevance to her country; many of the people lived in trees because they had no homes. She also noted that while we Westerners hail Florence Nightingale as the "founder of modern nursing," in her world the founder was a compassionate male monk.

When I contrasted her story to that of Vasu, who was using his life and work in India as the context for his learning adventure, I became determined to find a way to make this international nursing school a reality for our profession.

The "doctors" engaged in healing systems reflect the culture of their countries; for example, acupuncture is a prevalent healing method in China, science and technology in the United States, and spiritual healing in indigenous cultures worldwide.

Nursing, on the other hand, is a universal phenomenon. It is about functional health patterns: Pain, mobility, nutrition, elimination, general health, and spiritual well being. A colleague at the World Health Organization had always held that countries progress when the women, primarily nurses and teachers, work together with the children. They are the ones who transform the standard of living. Nurses worldwide, connected in dialogue and discovery, would be a vital catalyst for enhancing the health of people around the world.

As I was preparing to end my sabbatical in New York during the early part of Kristi's pregnancy, I received a call from Don MacIntyre. He had just resigned from the Fielding Institute to join an Internet start-up company interested in using the concept of distance learning to build an international nursing academy. He was to bring with him someone from the world of nursing who could help the company realize its vision. With great delight we joined this company and the

dream was launched. However, as Kristi's illness progressed, my ability to focus on the work became increasingly hard.

It became a delicate balance act juggling Kristi, and the requirements of presence and prayerfulness for her recovery, with the demands of a new start-up venture. With only a month remaining until delivery, our whole backyard was filled with the color and beauty of prayer symbols, as well as the angel statue that had graced my flower garden from the day we moved in.

When my extended family came to celebrate Easter, the prayer ties evoked discomfort among them. My intensely maternal "protective she-bear instincts" provoked me into trying many things I may not have previously considered. When the health and well being of my children were at risk I opened myself up to all possibilities. In this case, I was learning the most difficult and powerful lesson of *receiving* a gift from a friend; in fact, a whole community.

As a nurse, I found receiving help such a hard thing to do because we are most accustomed to serving others. Many of us go into nursing because we like to serve, and often, I fear, in a co-dependent fashion. Nurses of my generation were social-ized to believe that it was our task to create a perfect plan of care for the patient. If we did not maintain this, we were labeled "non-compliant." It strikes me that today the health-care industry has been forced to hire compliance officers for society has given that label back to us. Moving from the role of "expert who directs" to "novice who receives" was a total role reversal; I was undone.

With regard to Kristi's situation, I was forced to admit I did not know what to do. None of my training, experience, or

knowledge was working. All of my tried and true methods had failed. The healing that *was* working came from an obscure and oppressed community that stepped forward with sacred gifts of presence and prayer, asking only that we receive them and give prayers of thanks. This whole experience was a deeply profound lesson in humility.

For four generations Dennis's people have been farmer-ranchers, caring for the land and animals. He is a wonderful provider who deeply loves the earth. He is also very conservative, and my adopting the Sioux rituals challenged his religious upbringing. It became a strain between us, for he could not understand that I was really praying in two languages, offering all that I had to God in two different and beautifully complementary ways.

Three months of total bed rest, twenty-one ultrasound procedures, and the healing ceremonies of the Wasa Wapka community and the family all helped Joshua Joseph enter the world. A scheduled C-section delivered Kristi with a most beautiful and healthy child. Overjoyed, we felt the whole childbirth trauma had finally ended.

Joshua, who was promptly nicknamed JJ, was born with thick black hair and piercing eyes. However, he had severe colic and for the first six months of his life he never slept more than an hour at a time. Most of his waking time was spent in screams and cries that had no end. When taken to the pediatrician's office, JJ's parents and doctor had to step into the hall to converse so that their words could be heard above his miserable little cries.

JJ was not alone in his discomfort. Alarmingly, Kristi's health after his birth didn't improve, but continued to deterio-

rate. I remember the moment I realized that she was taking a turn for the worse. The scene from the movie "Steel Magnolias" where the young mother dies flashed in my memory, and the gnawing fear that had flickered within me throughout her pregnancy became a roaring flame.

The Manifestation of Five Stones

After JJ was born Kristi continued to experience high blood pressure, often times at levels that portended stroke. The perinatologist calmly said that this was not unusual for someone who had had her prenatal experience, and that it would shortly disappear. Kristi was unable to return to work, and she was instructed to stay off her feet as much as possible. This created a quandary for me as I had put many things on hold while caring for her during the last three months of her pregnancy. Work-related travel I had rescheduled kept me out of town for much of JJ's first month of life.

I continued to work with the Internet start-up creating its e-learning nursing curriculum, which was a core component of the international nursing academy. However, many of the concepts which had been so dear to me now felt mechanical and technical in nature. I tried to discern if this was because the curriculum's delivery medium was technology or if it was something deeper.

During this same time I had the great privilege of working with Dr. Jean Watson, who had done path-breaking work in the areas of caring and transpersonal nursing. She had been assigned the task of creating a Web-based course on caring. The big debate focused on the possibility of establishing an

authentic and meaningful relationship virtually (over the Internet) versus face-to-face interaction. We had many significant conversations around the meaning of having an authentic presence and connectedness when the parties involved were remotely located. It was Jean's power and clarity of vision for what nursing really was that helped me see its natural affinity to indigenous healing traditions, especially if the technology and medical practice aspects of the work were removed or transcended.

Kristi had a particularly difficult night while I was on an extended trip trying to build support for the academy. The pain she was suffering in her back was more severe now than during her labor experience. At 6:00 A.M. the next day, a Saturday, Eugene told her to go see a physician while he took care of their two small children.

Kristi went to an urgent care center managed by one of the local hospitals and was seen by a pediatrician, a child specialist who was the only doctor on duty. He examined her and told her that her symptoms sounded like the passing of a kidney stone, but he could not be certain because she defied the typical patient profile of one who created stones. The typical patient was an elderly, and often overweight, male or female. The physician reviewed her x-rays and sent Kristi to the main hospital for an ultrasound.

After being admitted for an outpatient procedure, she found her way to the Radiology Department and gave the technician on call the order. When the ultrasound was done, she was asked to wait in the adjacent waiting room. Feeling very ill made the wait more difficult. After ninety minutes she went back to inquire about what to do next.

The technician looked irritated and snapped, "How am I supposed to know? I take the pictures and that's where my job ends." She instructed Kristi to see the receptionist.

Kristi was well aware of the challenge Eugene was facing at home with two small babies. Concerned about them and still feeling ill, she asked, "When can I talk with the doctor?"

The receptionist replied coldly, "Well if you want to talk to him, you'll have to call him yourself," and handed Kristi a handwritten preliminary report from the x-ray.

Never having seen this physician before, Kristi had to ask for his phone number. Again the reply came back. "What do you think I am, a walking phone book? I don't have his number." She handed Kristi a telephone book and Kristi found the doctor's number herself.

She was able to connect with the physician and read him the scribbled note. The physician said, "Ask the patient if these symptoms have occurred before," to which Kristi replied, "I am the patient."

The physician became very angry and demanded to speak to the technician. The receptionist found the technician, and after a heated phone exchange between the two health providers, the technician told Kristi to go to a local drugstore where the doctor had called in an order for medication. He added that she should go back to her perinatologist on Monday. Kristi returned home with an order for an antibiotic, and no real answer to the incredible pain she was experiencing.

When Monday came she called her physician, who simply said, "Well, if you passed a kidney stone it must be gone, so just drink lots of water."

By now Kristi had been on potent blood pressure medicine for six weeks. Pounding headaches and blurred vision revealed that they had had little or no effect because her pressure continued to rise instead of drop. JJ was keeping her awake night and day with his colic, and during the night his outbursts woke his brother. She was on her feet around the clock and started manifesting other symptoms, including deep joint pain that made lifting and navigating stairs almost impossible.

To enable Kristi to heal, our family devised a schedule: During the day Kristi would keep JJ while I worked. At 6:00 P.M. I would pick him up and keep him through the night so Kristi and Eugene could get some sleep, though Ethan was now waking several times a night as well. On the weekends Dennis and I took both boys for the morning shift so their parents could get a few hours of badly needed sleep.

Two difficult months went by with all of us becoming increasingly exhausted. Kristi's official maternal leave was ending, so she went to the physician for a physical exam to get a release to return to work. By now she had been off from work for five months and feared losing her job. The physician, noting her increasing blood pressure, doubled her medications and suggested that she stay home and rest as much as possible until the pressure and related symptoms subsided. Kristi came home discouraged and feeling miserable. She suffered continuous headaches from hypertension coupled with severe joint stiffness and recurring deep back pain.

My daughter was not improving; in fact, all of her symptoms were intensifying. After three more weeks of pleading, I convinced her that it was time to go to a kidney specialist and have another expert opinion on the cause for her hypertension

and possible kidney stone. I arranged for her to see one of the leading experts in the medical community the following week.

I had made a prior commitment to deliver an address with Jean Watson at the American Holistic Nursing Convention, which required that I be in Arizona for a few days. While it was painful to admit, it was a relief to have a bit of time and space away from the intensity of the issues at home. The minute I stepped on the plane I fell into an exhausted sleep and woke only long enough to find my way to the hotel. It was while I was flying to the convention that the medical kidney specialist in Sioux Falls was seeing Kristi.

The doctor spent all of five minutes with her, looking over the lab work and vital signs obtained by his office nurse. Kristi explained to him her experience with what another medical expert had thought was a possible kidney stone, though no one had ever confirmed that diagnosis. She described to him her continued back pain, the stabbing sensations that would wake her, prompting her to move about in search of relief. He glanced her way and told her that she was female, thirty years of age, and that stones were not part of that reality. He dismissed her with instructions to stay on her current course of treatment.

The next morning I awoke to a warm Arizona sun and got ready for the day, eager to spend some time with a part of the nursing community that was especially dear to me. I had always found the nurses who practiced holistic healing had a philosophy akin to my own. Each "tribe" within the nursing profession has its own unique set of qualities. It is those qualities that help them excel with specific patient populations. Critical care nurses thrive in crisis situations and have great

prowess with technology. Hospice nurses facilitate the dying process for patients and their families. Holistic nurses view health as a body-mind-spirit phenomenon and work with modalities of energy, nutrition, relationship, spirituality, and balance. For me coming to this meeting was like coming home.

I went down to meet the shuttle bus to catch a ride to the Phoenix Convention Center where I would be speaking when a sudden sense of deep dread swept over my body. Just as the bus arrived I quickly grabbed my cell phone and placed a call home to Kristi.

I took my place on the bus amidst a group of other nurses going to the convention center, the phone pressed to my ear, when a strange voice answered. It was Kim, Eugene's mother, who informed me that Kristi was in the hospital undergoing emergency surgery. No, she did not know what for, but I was to call Eugene on his cell phone and he would tell me. In a panic, I dialed his number but there was no answer. I called the hospital switchboard and asked to what room Kristi had been admitted, and was connected to a nursing station. No one knew who she was, where she was, or why she was there. After a long pause the nurse came back and told me that I should try the Intensive Care Unit waiting room and maybe someone there could help me.

By now I was frantic with worry. Did she have a stroke? Was it her kidneys? Was she conscious when she went into the hospital? Why was her husband in the Intensive Care Unit waiting room? Thoughts flooded my mind, and emotions of fear and dread overwhelmed me. Finally I connected with the ICU waiting room, where again no one could give me any help. At that point the bus was pulling up to the Convention Center,

and stunned, I put down the phone. Oh please dear God, I thought. Guide me. I can't think straight. What shall I do?

No sooner had I put the phone in my lap than a nurse across the bus aisle said, "I don't mean to intrude, but I could not help but overhear. Are you having a family crisis?" I looked into her kind eyes and began to cry, "It's my daughter. She has been ill and is in surgery and I cannot find out why."

The nurse said, "If it was my daughter I would simply go home."

Her kindness was such a comforting presence that I found myself telling her my dilemma: I had to give a presentation in less than an hour. She intuitively went to that wonderful space where nurses go with people in distress and said, "Let me help you."

She asked the person beside her to call the hotel and ask them to pack my bags. She asked the next person she could find with a cell phone to call the airlines and get my ticket changed to the next plane back to Sioux Falls. Then she walked me into the Convention Center to find Jean Watson, the person I was co-presenting with, to ask if she could cover the session by herself. Debarking from the bus, we entered the Convention Center and there, in a sea of hundreds of nurses, stood Jean Watson!

My dear colleague looked at my distress and asked what had happened. I tried to tell her but found myself unable to speak, so the nurse told her my story. Jean immediately ran into the street to flag down a taxi, and within minutes I was on my way back to the hotel. The cab driver was especially sensitive and caring, waiting patiently in the parking lot for me to pick up my bags. Thankfully the hotel had already checked me

out, so within minutes I was on my way to the airport. In less than an hour from the time I placed the phone call to Kristi, I was flying home to be with my beloved daughter. I had experienced the incredible gift of caring from my own professional sisters. Never before had I been a recipient of such kindness; it was a moment I will never forget.

I got home late that night and rushed to the hospital, discovering that Kristi had undergone surgery for a lodged stone that had nearly ruptured her kidney.

The night before, her pain had become so intense that Eugene got his mother to care for the children and he literally carried Kristi into the Emergency Room. Once inside, the attending physician was unclear as to what her problem was. He kept her in the ER for two hours of observation. A CAT Scan had revealed several large kidney stones lodged in both kidneys.

He was just in the process of telling her that she would be dismissed with the instruction of drinking large amounts of water when a kidney specialist from a neighboring hospital walked by. The Emergency Room physician asked the specialist to step into the room and check Kristi. He quickly examined her, and within half an hour she was in surgery.

Later he would tell her that her kidney was nearly ruptured and asked why she had waited so long. She told him that the prior day a medical kidney specialist had told her there was no possibility of a kidney stone. Up until the point that she was unable to move, she thought her condition was imaginary. It was a great gift of fate that this caring specialist had come along when he did.

One large stone was removed during surgery, and a long

tube called a stent was placed in her left kidney. The CAT scan had revealed a second stone in the left kidney and two stones in the right kidney as well. She had created a total of five stones including the one she had already passed. The physician told Kristi that the stent would have to be left in for four to five days before he would remove it in order to allow the other stone in the left kidney to pass. Then he would have to treat the right kidney aggressively as well. He instructed her not to lift anything and to maintain minimal activity until the stent was removed.

The pain from the stent was unbearable. Kristi could barely move. Pain medication hardly touched the throbbing. Her urine was burgundy in color.

I asked the nurses for lotion so I could give her a backrub and was told that the hospital no longer provided it for patients. If I wanted it I would have to bring my own. The only option at 2:00 A.M. was to drive to an all-night grocery store to get the simple supplies needed to comfort my daughter. Throughout my entire nursing career supplies like lotion and toothpaste had been provided to care for people who found themselves in the hospital as a result of an emergency. It saddened me deeply to see what was being eliminated as "cost-saving measures." I felt such a loss for both patients and nurses who are privileged to serve them in small but important ways.

Kristi was discharged forty-eight hours later and given a strict instruction that under no circumstances was she to lift anything or anyone. She was to stay on bed rest until the stent could be removed five days later. Her situation was becoming more complex, with a baby suffering from colic and a brother less than two years old. JJ was disqualified from daycare

because of his excessive colic, so I kept Kristi and JJ at our condo. Eugene would take Ethan to day care and bring him by for an evening meal before taking him home for the night. I would share night duty with Kristi and try to work during the day. I found myself up almost around the clock. A deep fatigue was setting in for the whole family. We all took great comfort in the fact that it would end shortly when the stent would be removed.

On the fourth day into Kristi's mandatory five days of bed rest, the phone rang. It was the kidney surgeon's office calling to let Kristi know that the doctor was going on vacation. He would return in three weeks and then remove the stent. Kristi was beside herself, as was I. I had her call him back and say that she would be most happy to have one of his professional colleagues remove the stent, to which the nurse replied, "He practices independently. There is no one else."

Neither Kristi nor I could imagine how she could tolerate the painful stent for three more weeks. What would happen if the stones in the right kidney moved and blocked her one otherwise healthy kidney? I encouraged Kristi to call the medical kidney specialist she had seen the day before her first surgery and ask if he would be willing to remove the stent. His office returned the call saying that this was not a procedure the physician performed and that she would have to go back to the surgical specialist.

By now the fatigue of the moment coupled with the deep disappointment of all the failures of the healthcare system pressed down on me. I picked up the phone. I returned the call to the surgeon's office and simply stated that I needed a referral to the Mayo Clinic. I intended to take Kristi to Rochester

and have the procedure done, and I told his office that I need-ed the referral that day. I closed by saying that if I received no referral I would simply show up in the Mayo Emergency Room and request service. Within twenty minutes his office called back. The surgeon suddenly had time to see Kristi a week later.

Ten days had passed since the stent had been inserted. Kristi eagerly returned to the surgeon, expecting to hear that the stone had passed and the stent would be removed. A CAT scan was performed, revealing that the stone in the left kidney had not moved. The surgeon ordered another surgery for the end of the week.

We were totally exhausted; all resources had been spent, making another surgery and nurturing JJ overwhelming hur-dles to manage. So I called my eighty-year-old mother and asked if she would come and spend the nights with JJ so I could stay in the hospital with Kristi. Bless her heart, she could! Arrangements were made and off to a different hospital we went.

Eugene stayed with Kristi throughout the surgery and well into the day until he picked up Ethan at daycare. I cared for little JJ. When Eugene returned home with Ethan, I went back to the hospital to stay with Kristi; I would not leave her alone. My mother took over caring for JJ who was still crying non-stop around the clock. When Kristi awoke she found that not only was the stent still in her left kidney, but a second one had been inserted into the right kidney as well. The pain froze her to the bed.

At this point I witnessed the kindest act of caring from any health care professional in Kristi's entire illness journey. Her night nurse told her that only twice had she cared for a patient

with two stents; it is almost never done. It would take twenty-four hours for the body to adjust to the stents and stop the spasms a foreign object created. For twenty-four hours the pain would be worse than brain surgery, worse than an amputation.

This kind soul told Kristi that she would be there for her in every way possible. She ordered a heating pad, and until it arrived she made one out of heated towels wrapped in plastic. She came into Kristi's room twenty minutes before a pain medication was available, and would offer it anyway. She provided lotion and mouth freshener, and turned her frequently in an effort to provide some relief. By now the kidney surgeon had gotten to know Kristi and was equally supportive. She received exquisite care, restoring my faith in the Western medical tradition to which I had dedicated a life of service.

During my thirty-five-year nursing career, I have been present to many people in their suffering. I had witnessed Kristi experience childbirth and C-sections, but I had never witnessed anything quite so difficult. Her body trembled with the pain. Her breath was short and gasping rather than deep and rhythmic. Her hands clutched the sheets, and her ashen face was drenched with perspiration. It was more than I could bear to witness—and there was absolutely nothing I could do for her.

Nursing refines one's capacity for compassion, for emotional relatedness, and empathy. It fosters the ability to enter into a shared space where the connection with the patient is so deep that intuitively you "know" what is needed without an exchange of words. This connection gives the patient a sense of "being seen," "being cared for," and "being cared about." It has been my experience that this kind of rapport is, for some

people, their first real encounter with caring for themselves, which at times transforms their self-care capacity.

Added to this intuitive knowing was the deep love of a mother's heart; Kristi is my other self. If ever I had wished for the power of the Gods to perform a miracle, this was the moment. Since that was not possible, my sense of inadequacy, frustration, fatigue, anger, sorrow, and fear raged through my being with a force that transcended every emotion I had ever known. I was shattered and yet captive of the moment. I had to stay connected. It was like standing with my finger in a live socket taking the volts of electricity and not being able to let go.

After an endless night, Eugene returned to take his shift at Kristi's bedside. His devotion to his family was so profound it taught me what "unconditional love" really is. I went home to care for JJ so that my mother could get some sleep. We kept shifting people and resources among us, walking numbly through each day until Kristi was back—with a stent in each kidney and totally bedridden.

The doctor said both stents would have to stay in until the stones came out of their own accord, or he would have to break them up with a lithotripsy machine. In this procedure the patient is placed into a heated tank of water. Powerful sound waves are sent into the body, directed at the stone, to shatter it into smaller pieces that can be passed through the kidney. This procedure is used in older patients only because hypertension is one of the long-term side effects. The small pieces could also seed her kidney for further stone formation. Kristi was so young for this predicament that all traditional methods for treating kidney stones would be inappropriate for her. That night my mother left, Eugene took Ethan home, and

Kristi and I lay side by side in bed staring at the ceiling. JJ was temporarily asleep in the other room. A deep sadness and despair permeated the room leaving us both wondering how to move forward. And most importantly, we wondered when it would end.

The next morning the phone rang. I picked it up expecting it to be my husband. Each day that he was unable to come to Sioux Falls he would call for an update on the status of his beloved daughter. The voice on the other end was not Dennis, but rather that of Wanigi Waci.

"Your daughter is very ill."

Hearing the comforting voice of my mentor and friend reduced me to tears and I sobbed, "I know she is, Wanigi Waci, but I have run out of ideas on how to help her."

"If you like, I can bring medicine to her, Jo," he offered.

Little did I know that his offer would take me into another dimension of health and healing, to a place I had never been before, a place that would explain the appearance of the five stones and the meaning they held for the women in my ancestry.

The Power and Beauty
of Indigenous Healing

Life became a blur of activity. Kristi's world in bed consisted of hot packs, cold packs, back rubs and foot massage, pain medications every four hours, drinking gallons of water, and frequent urination irritated by the presence of stents in both kidneys. Interwoven were frequent trips to the medical clinic and hospital for tests, x-rays, CAT scans, and the constant discouraging message of "no change." There were brief periods of rest or quiet, never more than several hours, coupled always, always with the companionship of pain that demanded its share of attention from us all.

Simultaneously there was JJ, a precious child trapped by

hunger and then hours of cramps and pain half an hour after feedings that would find him crying and screaming for relief. He too would receive hot packs, cold packs, aromatherapy, and massage therapy. Our world became one of short rest intervals surrounded with hours of struggle by both mother and child. Inter-woven into that scenario was eighteen-month-old Ethan who wondered what was happening to his world. His days consisted of daycare, a brief visit with a mother who could not even hold him, and then home to bed and nights filled with nightmares and longing. Eugene kept one side of his family afloat while I attempted to buoy up the other. Life became a lesson in endurance.

In the midst of this all I became acutely aware of several lessons. If one has a declared chronic illness, life is adjusted and accommodations are made. Each trip to the physician found us receiving the same message: "There is no explanation for all of this; we must wait and see what the stones will do. Until then, the stents must both remain."

The undetermined path and time frame prevented any long-term planning. We attempted to maintain 'business-as-usual" while responding to the immediate demands of the moment. A sense of unmanageable chaos permeated our lives.

The far greater lesson was one about suffering. I discovered that suffering is a dimension, much like time and space. In the dimension of suffering time has no relevance. There is no hurrying it in any way. One must learn to slow down to the pace of what is happening and work with the rhythms that it holds. All of life stops when suffering is profound. Focus leaves the external world and moves into an interior space, the

place of longing and the ultimate meaning of existence. It was into this space that Wanigi Waci entered.

Wanigi Waci
SPIRITUAL LAKOTA HEALER

My relationship with Wanigi Waci began with the work at Sioux Valley Hospital in the mid-1990s. It was very formal when we first met, but as time went on a deep and sustained friendship developed. Being invited into some of the ritual and ceremony of his tribe, I came to appreciate the qualities of his culture and his worldview. A real surprise was the discovery of his People's profound sense of humor and play. It would not be uncommon to leave an Inipi Ceremony with a string of empty cans and bottles tied to the bottom of my car, bouncing merrily all the way home. After a formal meeting I would be alerted to a clothespin clipped to the back of my suit jacket or coat only by people's chuckles as I walked by. Once after a strategic planning session, I drove away from the meeting with an inflated rubber glove tied to the grill of my car. It wildly waved at me and all that passed by as I drove home. Wanigi Waci was quick of wit and would always have something to say about a comment made. Once I sent him an e-mail about being in a "pickle," that is, I was in a difficult situation. His response was:

From: WW
To: JoEllen Koerner
Sent: Thursday, June 22
Subject: Lela Waste Elo (That's very good!)

```
Jo,
     So what's the big dill about the pickle theory??
     I'm sorry that wasn't very kosher was it!
     Get the cue-, cumbersome huh?
     Well, relish the thought.
WW
```

After several years I came to appreciate how deeply Wanigi Waci is connected to all of life, nature, others, and the spirit world. He would "know things" through communication in another dimension. At times I found it most unsettling.

One day I was writing a proposal that included his work and I thought, How can I connect with him? He is so hard to find!

At that very moment the phone rang and Wanigi Waci said, "So what do you want, Jo?"

I queried, "How do you do that? I can't do that, Wanigi Waci. Great that you can, but I need a fax, a phone, or an e-mail!" He laughed heartily.

When I left for New York for my sabbatical, Wanigi Waci told me about some of the hardships I would face. Being in an urban setting for the first time in my life, I never wanted to admit to anyone how difficult things occasionally were for me. I received the following message at a particularly low point in one of my assigned projects:

```
From: WW
To: JoEllen Koerner
Sent: Thursday, July 21
Subject: Peace
```

Hello, my friend,

Watch out the cyber cowboy is on line riding the airwaves! How…and I mean HOW (it's culturally appropriate) are you? I just wanted to remind you of how much you are loved and appreciated! RE-MEMBER in the circle of life the lowest point in your life is the horizon, for those who hold the opposite polarity remind us of where we've been and the possibilities of where we CHOOSE to BE. Until our paths cross, PEACE.

"Your peace may be the piece someone is looking for."

Wanigi Waci

While I was in New York I celebrated a birthday. I had never told Wanigi Waci when my birthday was, but the morning after my birthday I received this e-mail:

From: WW
To: JoEllen Koerner
Sent: Saturday, August 14
Subject: My Friend

Jo,

How are you my friend? Last night I felt your energy so I responded in this manner and returned your energy with great honor.

"Shout from the highest mountain tops
Silently feel what you think

The Universe listens equally"
Wanigi Waci

PS. If the Universe were deaf, what action(s) would
replace or express your Beingness?!

After rushing home to South Dakota to see my mother, I
returned to New York with a very heavy heart. Seeing her
struggle with aging, I experienced a deep loneliness and long-
ing to come home. I had not quite finished my sabbatical year
with the company, and yet the need to be home with my moth-
er was haunting me. Again, having said nothing to anyone I
received this note from Wanigi Waci:

From: WW
To: JoEllen Koerner
Sent: September 1
Subject: The can gleska (medicine wheel) is a ball!

Jo,
 This morning before the Grandfather Sun shined
upon the Earth Daughter I mentioned my awe and grat-
itude for being. Of a hundred million, billion of
the pauses in this creative process, some choose to
isolate in space and time. Here am I saying,
"Grandfather Sun and Mother Earth, what has changed?
Who has changed? Or, has it changed? Am I an echo
attempting to reflect the true origin of the essence?
Or, is the reflection in response to the reflection?
 Many times we are further away when we are physi-

cally close to our loved ones. It may be that it is not the absence that makes the heart fonder, but the fear of becoming so close that the letting go on multiple levels becomes too fearful. Only in realizing that there is no such thing as separation can true love be. Do the toes ever get lonely for the ears? If the ear is deaf can it still be a part of the purpose with the toes? All are but one of many bodies in creation. There are many mansions in the eye of the Sacred. So what is loneliness; a redefinition of our internal values to bring them in closer harmony with the Sacred (WAKAN)! In doing so the loneliness becomes Acceptance. The process is that loneliness is an awareness wake up call to redefine by reassessing, acknowledging, addressing and adjusting to realign oneself on the GOOD ROAD.

We are Spiritual Beings on the privileged physical journey. Even though we are already there, we have the privilege and opportunity to express our Beingness with free will and BECOME in humanness through the law of Grace. Harmony is in the hormones. Quiet the self and listen to the river of life flow freely in your bloodstream. Within the bloodstream is oxygen, the breath of life of the Creator and your direct link to all your ancestors coming directly from the Creator through your DNA!! This is the path home in these spiritual and human experiences. We Lakota call this Canku Luta, RED ROAD!

Wanigi Waci

It was from the depth of this relationship and consistent communication through a spiritual dimension that Wanigi Waci called to acknowledge my daughter's continuing illness and once more offer healing from his people.

The Oglala Medicine Man

Wanigi Waci called to tell me that Kristi's health was not improving, and that if we wished, he would arrange for us to meet with the Medicine Man on a nearby reservation. By now Kristi was very weak, her energy depleted and a sense of subtle despair had set in because the pain was so unrelenting. When I shared Wanigi Waci's offer with her, she immediately lit up. She had such deep respect for him and had experienced the power of his presence before. She quickly and enthusiastically agreed.

A Wase Wakpa community elder called to guide me in preparing for the event. Once again I had to create prayer ties, plan a feast of *Wopila* (thanksgiving) for those who would come to support Kristi in ceremony, and obtain give-away gifts for the Oglala Medicine Man and his helpers. I asked for my mother to help Eugene with both JJ and Ethan. She was getting deep satisfaction from being "needed" and had developed a very special relationship with little JJ. Interestingly, she demonstrated more strength and energy than I had seen in her for some time.

I gathered up all the needed materials and sat through the night in prayerful preparation, making prayer ties and flags. The next morning Kristi and I packed the car and left for the reservation.

Both Kristi and I were quite apprehensive, not knowing what to expect. I had a colleague who had been invited to a similar ceremony. The Medicine Man saw his cancer and told him that he had a short time left to live, and encouraged him to go home and spend quality time with his family. I was not sure I could handle the truth if it was not favorable to Kristi's life and health. But I also knew that we were at a crossroads— nothing was helping her.

The July day was particularly beautiful. I can still see the clear blue sky and the huge white clouds that dotted the horizon. As we drove through the Badlands, the colors on the spires were especially radiant. I felt so alive, so present to the moment. A deep sense of excitement and anticipation surrounded us both. As directed, we came to a small creek and drove up the hill, arriving at the designated sacred site. It consisted of a small white house on the top of a hill with a vista of the Badlands that went on endlessly. There were no signs of civilization. It was truly stepping into a timeless space, and the beauty and peace of that place stays with me to this day.

Shortly after our arrival the Elder and his wife drove up. With their help, Kristi and I set up a portable table, placing on it a small camp stove to begin preparing the meal. Kristi sat on a camping stool and helped as she could. While we were busy cooking, a summer storm gathered on the horizon. Winds began to blow wildly as the sky got black with boiling clouds. All around us sheets of rain fell so hard that we could hear them roar as they hit the ground. I inhaled their delicious scent. Amazingly, not a drop fell where we were sitting.

Suddenly Kristi cried aloud, "Look Mom!"

To our right the storm was raging, while to our left a cloud

had parted, allowing a long silver beam of light to shine forth. It created the most incredible double rainbow I have ever seen. The rainbow arched the entire horizon before us. We both were awed at its beauty and by the promise it held. Many times later, when Kristi was in her darkest hour, she would comment on the beauty and serenity of that moment. Its power carried us both.

As darkness fell on the land, the Oglala Medicine Man and a host of people, including several cars of Wasa Wakpa Community members who had driven all the way from Vermillion, began to assemble around the white house. An Inipi Sweat Lodge Ceremony was held for cleansing and preparation for the Healing Ceremony. Because Kristi was so weak, she and I were allowed to stay by the cooking fire and prepare for the feast.

After the Inipi Ceremony was complete, Wanigi Waci and the Elder told me it was time to meet the Oglala Medicine Man and tell him why I brought my daughter and what it was that I wanted from the Creator. I had to go alone to make my request; protocol declared that the mother would offer the petition on behalf of the daughter. Kristi was to stay back at the campsite. The Elder gave me his pipe filled with sage and tobacco, and escorted me to meet this incredible man.

The Oglala Medicine Man and Wanigi Waci were standing in a clearing at the edge of the camp—waiting for us. I looked at my dear friend, Wanigi Waci, who was standing along side me, guiding me in English, and translating to the Oglala Medicine Man in Lakota. A striking Native American male in his mid-forties, he was dressed in his usual style of jeans and a ribbon shirt. His long black hair was tied back, and the large buckle on his belt shone in the light of the early night stars. His

beautiful brown eyes, which seemed to hold witness to many dimensions simultaneously, were filled with compassion. His hands, gentle while roughened from working with the earth, held the pipe as he offered prayers in the sacred way. His voice dropped when he addressed the Creator.

I felt safe and cared for as I stood beside my friend while he guided me through the appropriate protocol. I thought, So this is what a patient feels like when a nurse stands by. I was filled with a great sense of awe of the wonderful essence of a healing moment.

I handed the pipe to the Elder who then handed it to the Oglala Medicine Man. He asked, "So what is it you are seeking?"

I looked into his caring eyes and with tears brimming my own I said, "For four generations the women in my family have struggled with childbirth. My great-grandmother, my grand-mother and my mother lost their mothers in childbirth. My mother and I both almost died when she gave birth to me. I lost two children before having the twins. And now, my daughter Kristi is ill. She almost died in her last delivery and she cannot seem to recover this time. My deepest prayer, if it is the will of the Creator, is that she will be granted health and recovery so that her children will not experience the life of an orphan."

He looked deeply into my face and then at my forehead. Suddenly his eyes widened as he recoiled. I quickly bowed my head. I knew that he had seen something and it frightened me beyond belief. My heart started to pound wildly, while a dark fear crept inside. There was total silence for a very long time. Afraid to look up, I assumed that he was praying. He spoke a few words in Lakota and gave back the pipe to the Elder. We then moved to the white house.

By now it was totally dark outside; only a few stars were shining through the clouds that covered the moon. Inside the house the windows were covered tightly so that no light could enter. The food prepared for the feast, as well as special spirit food, were placed in the center of the room.

Then people slowly filed into the house, seating themselves in a large circle. Forty to fifty people had come to share in the healing ceremony for Kristi and two others, one of them being Wanigi Waci's own daughter who also was suffering from a kidney disorder. Kristi and the other two individuals were seated directly in front of the Medicine Man, with me placed at Kristi's left side. When all was ready, the doors were closed and a deep darkness wrapped around us.

Once all the people were settled, a quiet fell over the group and the Oglala Medicine Man set up his altar. It was a simple and eloquent altar made of a plywood square with four coffee cans filled with sand standing for the four directions. Spirit flags were placed in the containers, along with other spiritual objects. The plywood altar was then covered with the prayer ties we had made, as well as ceremonial flags and other healing symbols he had taken from his medicine bag. After the altar was assembled he offered prayers.

The Oglala Medicine Man asked a question in Lakota, which Wanigi Waci translated, to me. "Why are you here, and what is it you are seeking?"

The other two people went first, speaking in their beautiful native tongue. Then Wanigi Waci said, "JoEllen, tell the people why your daughter is here."

Speaking into the darkness that surrounded us, I began with an apology that I could not speak their language. I repeated

what I had said to the Oglala Medicine Man, and I thanked them in German for the gift of sharing their healing ceremony with us. Kristi reached over to me in the dark and we squeezed each other's hand, love flowing between us.

Softly the Medicine Man began to pray. Then the helpers started to sing and drum piercing songs that were offered to the Creator. Suddenly in the darkness sparks of light began to flicker high in the air. They were slightly larger than a firefly and blue in color. The sight of them made my heart leap with joyful recognition: The Spirits had come! As the prayers, songs, and drumming continued, the Spirit flashes increased. The Medicine Man then asked Kristi and the others to stand. Suddenly she was surrounded by a vortex of whirling light. A loud rattling sound accompanied the swirling energy, and she was tapped repeatedly at various parts of her body, especially over her left kidney. Later we were told that total darkness is essential because when the Spirits enter the house, they see Kristi's body as a silhouette. Wherever illness or injury exists it appears as a pinhole with the light flowing through. Spirits are drawn to the light and tap and heal the places that show up in this way. I was struck how the process was really a spiritual CAT scan.

Over and over again this scene repeated itself, and suddenly the Spirits were gone. It grew quiet except for the sound of the Oglala Medicine Man's prayers. He sat in silence, and then the lights were turned on. People from the outer circle were invited to offer prayers or comments. One man shared how he had been deeply depressed over the loss of his father a year earlier. During the ceremony the father appeared to his son, asking him to put his grief down and use that energy to help the People. It was a profound healing experience for this man.

Many people both in the center and the outer ring of the circle experienced healing in multiple ways.

A dish of spirit food was prepared as a thank-you offering. The young men served the gathered people. After the feast, give-away gifts were offered in appreciation by those receiving the healing, and the ceremony ended. It was well past midnight when we left the house and went back into the night. The stars were now out with all their brilliance. Wanigi Waci asked Kristi and me to join him with the Oglala Medicine Man. My legs felt like rubber. I could hardly catch my breath as I was so frightened by what I would hear.

We went before the Healer. He spoke, "Kristi will be healed if she chooses. All will be well. The choice will be hers."

My relief was so profound I thought for a moment that I would pass out. In my joy at the possibility of her recovery I missed the implication of the phrase "the choice will be hers." I had so many questions, but looking at both Wanigi Waci and the Oglala Medicine Man I knew that it was not the time to ask them. With profound gratitude, we thanked both men and walked away.

Wanigi Waci came up to us and said that Kristi would need special medicine and that he would bring it to her after he gathered it. He also said he would tell us more when the time was right. We got into the car and drove to a small hotel nearby so Kristi could get some sleep. It was 3:00 A.M. when we crawled into bed totally exhausted and amazed by what had just transpired. Wanigi Waci stayed up all night and prayed for the People—and for Kristi.

The ride home the following morning was an unusual one. We tried to discuss what had happened. Kristi was so con-

founded by what she had experienced, she was unable to make any sense of it. Being more detached, and having experienced many of the ceremonies of the Lakota community, my sense of it was different. We both agreed that something very sacred had occurred, but that to share details with the rest of the family would be most difficult because they had not experienced it.

And more honestly, we could not articulate what we had experienced because we weren't able to explain it using our Western religious worldview.

Sundance

After the encounter with the Oglala Medicine Man, Kristi and I tried to take another perspective into our exploration of illness and health. We began to probe the reality of multiple dimensions, reviewing stories in our culture about helper angels and spirits. We also began to examine beliefs about illness and its causes from our German Protestant cultural point of view, a scientific point of view, and an indigenous point of view based on what we had experienced on the reservation. Some of the doctrines, such as "illness is a punishment for evil," did not fit well with our understanding of the unconditionally loving God we were coming to know intimately in the course of Kristi's illness. Slowly we were moving into a new way of viewing and exploring the situation in which we found ourselves.

However, we still were exhausted, exasperated, and impatient for the stents to come out and the long dark journey of suffering to be ended. At that point the phone rang again. Wanigi Waci was extending an invitation for Kristi and me to attend the Sundance on the reservation the following week.

Scheduled to last for four days, Kristi was to come on day three, the day of healing.

I asked my mother once again to help with JJ, as the two were becoming fast friends. We affectionately dubbed my mother "Queen of Patience" as she had a magical way of quieting him in the middle of the night without getting caught up in his cries of pain.

We arose early to reach the dance site by noon. Equipped with food and supplies for the dancers, we drove the now familiar route that had taken us to the Oglala Medicine Man a few weeks earlier. This time we drove past the small white house, down into a deep gully and a most beautiful setting. A large arbor had been created with a roof of fresh-cut branches, forming a ring of shade for drummers and family and friends who were there to support the dancers. Just inside the arbor was a ring of prayer sticks and prayer ties. Located at the center of the circle was the large Tree of Life that held bundles of prayer ties and flags.

By the time Kristi and I arrived the dancers had been active since sunrise. The circle was filled with men and women dressed in ceremonial garb, praying to the great Creator through song and dance. One young man was tethered to the tree by two ropes attached to small bone spikes pierced into either side of his chest. This piercing was performed in the spirit of suffering for the healing of the People.

Kristi turned to me and said, "See, Mom, he has a stent on each side too, but on the outside." He became a symbol of what Kristi was enduring. It was a powerful experience for us to witness his courage. We drew great strength and insight by watching him progress through the day.

Each prayer session found the dancers bringing sacred pipes into the circle. After the dance ended the pipes would be given to people under the arbor to share in a prayer ceremony. When the Elder gave me a sage bundle, I knew I would be privileged to receive one of the pipes. A specified number of us were lined up around the prayer tie circle and instructed not to look at the dancer, to keep eyes averted to the ground. With outstretched hands holding the sage offering, I stood with the others listening to the songs and the drums pulse in rhythm and harmony as the dancers and supporters offered prayers for healing. Suddenly a pair of bare feet appeared before me and I felt the weight of a pipe being placed into my hands on top of the sage bundle. As the last pair of feet danced out of the Sundance circle, I was invited to take the pipe back to my circle.

The same group of people who had prayed for Kristi before JJ was born and who had joined her at the Oglala Medicine Man healing had also come to the Sundance. We all gathered together under the arbor, and as the pipe was passed with deep gratitude around this circle, each person was invited to pray for the healing that they were seeking. I then had the privilege of giving the pipe to an Elder who was sitting with his walker by the edge of the Sundance circle. Deep cataracts clouded his sight, but he took the pipe with great respect and offered the last bit of tobacco as he lifted the smoke heavenward. He held it for a long time, then looked deeply into my eyes and said, "'Thank you." As we exchanged greetings a large hawk flew low overhead and Grandmother came to mind.

Wanigi Waci had explained that each year when the Sundance is held, it is scheduled on the hottest days of the summer when the sun is at its zenith. For four days and nights

the dancers go without food or water, blowing on eagle whis-
tles (which dehydrates them further) to offer their sacrifice on
behalf of the People. This ceremony gives the dancers insights
that cannot be acquired in daily life. It also allows them to sac-
rifice for the People and give back to the Creator in a tangible
way. A year earlier after the Sundance he had written:

From: WW
To: JoEllen Koerner
Sent: August 3
Subject: Sun Dance

Jo,

I'm back! Just a little crispy but ready to go!
One day it was 114 and the next was 115 degrees F.
The second two days it cooled down to 90! Four days
dancing without food or water in that weather makes
one realize the beauty of this earth existence in
all its solidness.

Only when we attune our inner resources to the
greater endless natural resource of the original
essence is it possible to understand the infinite
minuscule contradictions we place on the rational
existences we call earth existence. Here we become
aware of the incomprehensible vastness OF, for the
OF is an interplay in co-creation.

So let's harmonize our abilities for the beauti-
ful dances of the universal essences to materialize
that which is good. Realizing that we create and
design all these things to help others is a beauti-

ful concept. We need to understand that personal
commitment and integrity in creation is essential to
manifest the better good.

In true essence, we are all one so all that is
done we do to US! And in the end it is done in,
through, for, about, the incomprehensible Creator!!
It is beyond us, for us, about us...SPIRIT MATTERS!!
WW

A flesh offering was an option provided to the people who did not dance within the circle. I left Kristi in the car to rest as I decided to join this part of the ceremony. I took my place in the long line as a cold rain began to fall.

As we approached the elders, some of the tribal members explained the ritual and its meaning. They took a sterile needle and lifted the skin on my left upper arm, cutting off a small piece and placing it into a prayer tie. All ties were placed at the sacred tree in the center of the circle as an offering for the healing of the People.

Just as this was done the rain became intense. I was wet and freezing when a warm coat was gently placed over my shoulders. Kristi, anticipating my discomfort, had slipped out of the car to bring it to me. Together we ran through the rain back to the car just as it started to hail. Huge hail stones the size of softballs came hurling to the ground. The dancers went into a teepee for shelter, and the whole ceremony was suspended.

Wanigi Waci had told me that each year all four seasons are experienced during Sundance. This was the winter he had predicted. After what seemed like an endless stretch of time (time enough to damage our car) the hail passed. Mounds of

white covered the ground as people slowly found their way back to the prayer circle.

All of the people gathered were invited to step up to the prayer tie circle as the dancers gathered within. The dancers formed a long line and went around the outer edge of the prayer tie circle touching each person standing along the rim with sage and a prayer for healing. Young and old, infants and children, all interacted in a beautiful ceremony of song and dance, lifting up prayers for the health and well being of all the creatures of the earth, as well as the earth itself. Once again no one was allowed to look at the dancers, discretion being the order of the day. However, when Wanigi Waci came dancing past us, he touched Kristi on each shoulder, and then once again on her left side. She smiled at his acknowledgment and wondered again how he perceived the world.

We left the ceremony fortified by the power of what we had seen and experienced, knowing that something profound had occurred. Healing was taking on a whole new meaning for us both.

Indigenous Healing Merges With Western Medicine

Two days after the Sundance Kristi had another appointment with the physician. A CAT scan was done. It revealed that the stones in the right kidney were gone; only the large one in her left kidney that had been discovered during her first surgery remained. It was time for one of the stents to come out! Overjoyed, she went to the clinic for the procedure. The physician said that it was a simple office procedure that would take fifteen to twenty minutes maximum. I waited with joy and gratitude. After an hour had passed, that all-too-familiar sense of dread and concern began to play in my body.

Disentangled Medical Care

Finally Kristi came out of the office and we quickly went home. On the drive to the condo she told me that the two stents had gotten tangled together, and that as the physician pulled to remove one stent, the second one became dislodged. The physician struggled endlessly to disentangle them while he was inside her body, and so by the time the procedure was finished she felt great discomfort. However, he had assured her that all was well and that she needed no pain medication for it had been a removal of no consequence. I took her home, and she lay down to sleep.

She was awakened by the arrival of Eugene and Ethan who were eager to see their wife and mother free of one stent. The assumption we all had made, as reinforced by the physician, was that she would be able to enjoy limited mobility once again. Suddenly Kristi rushed into the bathroom and when she came out she was white and drained. Severe pain permeated her lower back, abdomen, and entire urinary tract. Deep burgundy blood was present in her urine. Alarmed, I asked if she wanted to go back to the doctor; she quickly said no. Her pain increased until she was back in bed taking short gasps rather than breathing deeply. Little Ethan got so scared that Eugene was forced to take him home so he would not see his mother in such pain.

Together we went through another long and sleepless night. I kept putting hot packs on her kidney area. I placed her in a tub of warm water to stop the spasms that caused her to urinate every fifteen minutes, with almost no output. I forced fluids, gave aspirin.

I was waiting for her doctor when the doors of the clinic opened the next morning. His nurse came in first.

I stepped up to her and said, "Today you will do *something* for the pain my daughter is experiencing. It is inhumane for a person to endure what she has been going through all night. I do not care what you do, but I am going home to get her and when I bring her back you will do something."

I was sobbing as I said this, and this very caring nurse assured me that indeed they would do something for Kristi.

I went home and gently helped Kristi into the car, taking her back to this all-too-familiar place. As soon as we arrived the nurse put her into an exam room, and the caring, capable, and concerned physician entered. He admitted that he had some difficulty and that maybe he should have warned her that she may have spasms. He quickly ordered medication and started an IV.

He told Kristi that she would spend the next four hours in a sedated sleep. In true Kristi style she asked, "Don't you need this exam room for someone else?"

The physician was startled by her thoughtfulness and said, "Well, if we do, we'll just move you over and you'll have to share this table with them." We all laughed at that image, and Kristi quickly fell asleep.

While she was sleeping I drove to a nearby park that had been my meditation spot for all the years I worked at Sioux Valley Hospital. It was a beautiful greenway on top of a hill overlooking the city below. During my tenure as a nurse executive at the hospital, whenever I was having a challenge or needed inspiration, I would skip out during the noon hour and drive to this spot. It was always a place of comfort and clarity. As

I sat there again that day I was greeted by a hawk. I made special petitions to God for a miracle that may help Kristi heal. Each event to date had seemed to intensify her suffering until I could not imagine any more. My deepest prayer was for deliverance of Kristi from this whole unending experience.

Healing Herbs and Pharmaceuticals

When the four hours were up I returned to the clinic to pick her up. She was quite drugged, but I could see that she had gotten some rest. She said that the pain was less intense. As we drove into the driveway I saw a car—Wanigi Waci was waiting. As I helped Kristi into the house I saw him sitting by the picnic table on the patio, working with some branches and leaves. After putting her to bed I went outside to join him. He looked at me so compassionately I almost wept.

"Jo, Kristi's intense suffering is your Sundance piercing." His acknowledgment of my own suffering as a result of hers was very comforting.

"Kristi is having very deep and intense pain," he went on to say. "I have brought her the medicine."

He then proceeded to sort through various herbs, leaves, and small twigs. He cut the twigs into tiny pieces, gently and with deep reverence. We sat in silence as I watched him make his preparations. Then he tied the various sorted piles into different colored cloths. He wrote a number on the tie of each one, indicating the order in which they should be taken, and we carried the finished products into the house.

He requested a kettle to cook up a broth of tea for Kristi to drink. He showed me how to smudge myself, Kristi, the work

area, all as a prayerful way of acknowledging the healing power of the plants while giving *Wopila*, thanks, to the Creator for these healing gifts. We stood in silence as I watched the small twigs dancing in the boiling water. Suddenly the pot became effervescent, similar to a glass of Alka Seltzer when the tablets fizz. When it was finished, I took a cup of the tea into Kristi's room and told her this was for her pain.

I went back to the kitchen where Wanigi Waci sat at the table. He began to explain. "Jo, in your way you make artificial medicine, and it is about your wisdom. You design one medicine to treat the heart, another to treat the lungs, and so on. In our way we always work with natural things. Each living thing has its own intelligence; we do not tell it what to do or where to go. Because you classify everything, you ask, how do you know which herb treats what disorder? In our way, we simply trust and respect the innate wisdom of the plant to know where to go and what to do."

He went on, "This medicine is for Kristi only. If you were to take it there would be no effect. My respect for nature and all things is from the heart; it is total. I have such deep respect for natural things that when I speak to them they can hear and recognize my voice. I walked ten miles on the reservation where the natural remedies grow and asked, 'Which of you would be willing to give your life to heal Kristi?' One by one they would signal to me that they were willing. And so, these plants are here for your daughter.

"When she takes them they will know what part of her body needs something and go directly to that place. There they will work with her on the DNA level. She will heal deeply, and completely, in that area. When she dies her body will return to

the Earth Mother, and the wisdom gained from the interchange between the herbs and Kristi will be given back to the earth to recycle in another lifetime for other healing work. Nothing is ever lost; all is retained in the great Circle of Life."

As he finished speaking that comment we were both startled to see Kristi standing in the kitchen doorway. I looked up and was stunned by what I saw! For nine months she had been dealing with deep pain that had turned her face into a taut mask of suffering. But here Kristi stood, the soft and familiar face of my beloved child visible for the first time in so long.

She was radiant and smiling as she quietly declared, "Mom, I have no pain!" Kristi went on to describe her puzzlement. "When I was at the clinic they were very nice to me. The medicine made me sleepy and the pain got less severe. But there was always, always this spot (and she referenced the back where her left kidney resides) that ached. It has never stopped—until right now. It's almost as if this medicine knew where to go!"

I looked at Wanigi Waci, and he smiled broadly.

Wanigi Waci invited us both to sit down. As she was now pain free, it was time for him to share the rest of the insights gained from the Oglala Medicine Man exchange.

Slowly Wanigi Waci began his explanation of our story. "Kristi and Jo, you two come from a wonderful family, a family with a heritage of many good things. However, it is also a culture that has an oppressive history for the women who live within it. The women of your family lineage who died did so because life was simply too hard for them, and so they chose to leave it. The two of you agreed before coming to this earth plane to live through this time as a way to heal that deep cul-

tural wound. When you heal, the healing will be extended to all the women of your lineage.

"Kristi, you have manifested five stones. In our way a stone is a keeper of the memory. These stones represent the five generations of women who have been plagued by death around childbirth; the stones hold their memory. Your earth body is the only thing you uniquely possess, a gift from the Creator. It is given when you are born and you leave it when you die. When people are oppressed they either turn outward or inward. The women in your lineage turned the oppression inward on themselves, and their bodies were destroyed. The key to healing this intergenerational issue is the notion of forgiveness. Jo, if you want Kristi to heal you must forgive all male oppression in this world."

His words staggered me. I looked at Kristi, whom I loved beyond my own life, and I thought of all the issues around patriarchy I had experienced in so many ways as a child. Images flooded my memory from the church and its male dominated leadership, metaphors, and language. I remembered how I felt as a nurse working with predominantly male physicians and administrators in both academic and health care environments. *How*, how could I possibly just move through all those years and transcend the negative memories and feelings that remained? I was suddenly aware of an enveloping heaviness that was from not only my own experience, but was genetically passed down to me from the women who had preceded me in the family. And if I could not transcend these negative feelings what would happen to Kristi? A feeling of panic ensued.

Sensing it, Wanigi Waci said to me, "Forgiveness starts with forgiving yourself."

Then he addressed Kristi with deep compassion, saying, "Kristi, for you the lesson is one of trust. In your way faith is the path to trust and healing. Faith requires belief in the intentions and power of another. We have faith that someone will heal us, save us, protect us. That faith rests on experiences that need to be repeated to keep the trust alive.

"In our way it is not faith but rather 'knowing.' Once we experience something we simply *know*, and in that knowing nothing ever needs to be proven again. You have now had an experience and you *know*. Let that wisdom be sufficient to heal you. You are already healed. You have only to realize it and know it at a deep cellular level."

And with that, Wanigi Waci picked up his things and left us sitting at the kitchen table, stunned by what we had just heard.

Two Paths, One Choice

After Wanigi Waci's departure Kristi and I sat at the kitchen table sharing a cup of tea and discussing the things we had just experienced. Memories surfaced of the stories told to me by my great-grandmother and grandmother. We examined moments from my childhood and Kristi's and contrasted them with the lives of all the women in our lineage whom we had known. We started to see patterns and connections invisible to us before the understanding gained from Wanigi Waci's comments.

Kristi and I suddenly gained an insight into her fear of my leaving whenever I dropped her off for flute lessons. Both my Maori *Fanu* (family) and Wanigi Waci's People believe that prior to birth, soul groups make a commitment for a specific work while incarnated on earth. However, the function of

choice gives each soul the option to complete the path—or not. The Oglala Medicine Man had been told by the Spirits that Kristi and I had made a pact prior to coming together this lifetime that we would change the pattern of leaving when the road gets difficult. However, we also knew that when all the other women in our family were faced with similar circumstances, they had chosen to leave rather than live through the hard times. At a deep level Kristi knew that her life path held a difficult encounter, and she had wondered if I would stay or leave as the others had.

We sat together in silence, reflecting on the powerful realization that there was truly a purpose behind all this suffering. I realized that my "choice point" came at the moment of my birth. Despite being premature and weighing only three pounds, I had chosen to stay.

For so much of my life I had seemed ill fitted for the place and life that had been mine. Often I felt more like an irritant than a blessing. No matter how hard I tried, I simply could *not* quiet my curiosity and then act on it. Suddenly, I felt compassion for my Self. I saw the young girl in the tree, the lonely teenager, the farm wife who wanted a career, and I saw a pattern that had prepared me to have the strength to hold space now for my beloved daughter. A resounding *KNOWING* swept through me: While life and all its vagaries are interesting, it is the growth of the Soul that is the essence of our purpose for gracing the Earth.

I tenderly looked at my daughter, admiring her own courage and commitment. I also recalled, as if hearing it for the first time, the Medicine Man's words "Kristi will be healed if she chooses."

A chill ran through me as I realized that she might have yet another challenge to face. "Please, dear Lord, heal my daughter—gently."

Kristi caught my eye, and I could see her overwhelming sense of fatigue. I helped her back to bed.

Shortly after, Eugene and Ethan came to spend the evening and dine with their wife and mother. Kristi got up from a deep sleep and the old pain began to return. No matter what we did, the intensity grew until Eugene had to take Ethan home so he would not be disturbed by seeing his mother in such suffering. After they left I went with her into the bathroom. Again the deep burgundy urine was present. Something was wrong. Her body was wracked by spasms and pain of intensity that would not be touched by either the medicine from her physician or Wanigi Waci.

By midnight the pain was so severe that she paced like a caged animal. I saw that she was in deep distress and told her I would go to an all night drug store for some supplies. I quickly jumped in my car and got the needed food and medicine. When I returned home and drove into the garage, Kristi was standing at the door waiting for me, causing my heart to beat wildly.

As I opened the kitchen door, I was shocked by the sight that greeted me. Any nurse who has worked around patients experiencing deep shock knows the syndrome: Their bodies are drenched in perspiration with a characteristic musty odor, their faces are drained of all color except for their blue lips and black sockets where eyes usually reside, and their hands flail in the air.

"Mother, Mother, I couldn't wait for you to come home. Something is happening!"

I was gripped by terror. Dropping the bags, I rushed to her side. I grasped her wrists in an effort to take her pulse, but she was unable to hold still long enough for me to get an accurate reading.

"Kristi, you are in shock. I am going to take you to the Emergency Room, now!"

She violently pulled her hands from me and said, "You will not! Each time I have gone to the hospital I have gotten worse. If I go back this time I will die."

I could see that returning to the hospital would not be an option for her. I pleaded, "Kristi, what do you want me to do?"

"I don't know, Mother, but I have to figure this out."

With that she began to pace in a circle like a wild animal in a cage. Round and round the kitchen we walked until a spasm so great gripped her side that she fell forward with the pain. I took her into the bathroom and filled a tub with warm water. I gently lowered her into the steaming bath and placed hot compresses over her left kidney. She stood up, sat down, laid down, stood up, and the spasms continued—nothing was touching her pain.

Suddenly she stood up and threw a washcloth at the wall while letting out a shriek of pain that will resound in my ears till the end of my days. With wild eyes she turned to me, tears streaming down her face and said, "No matter *what I do* nothing is helping. I have taken all the medical treatments and medicines, the indigenous treatment and medicines, and nothing touches my pain. And we still don't know if or when this stone business will end. I simply cannot bear this any longer."

Then came the moment of truth as she peered into my eyes

and asked in a calm and steady voice, "Mother, do you love me?"

Immediately I responded, "Oh yes, Kristi, I love you very much."

Again she asked, "Mother, do you really love me?"

"Yes, dear Kristi. Oh yes, I love you so."

She looked at me for a long moment and once again in a slow and deliberate way she said, "No, mother, I mean *DO-YOU-LOVE-ME*?"

What was she asking? What was behind this question? What was it Kristi wanted from me?

"Kristi, you are the most beloved being in my life. I love you more than life itself."

"If this does not change in two days, will you help me die?"

All of time stood still. I looked into her suffering eyes, observed a body marked with the scars of pregnancy and surgery, wasted from months of no appetite. I saw visions of her long-suffering compliance with all the things imposed upon her or requested of her and knew that this answer was the only thing left to give her hope.

A deep stirring inside gave utterance to a voice that did not belong to me, and I heard myself say, "Yes, Kristi, if that is what you want, I will help you die."

She stepped out of the bathtub and went to the bathroom, passing a piece of kidney tissue that had been torn in the removal of the stent. After a few moments the spasms began again, and once more we paced in a circle. I had brewed up some tea from Wanigi Waci's herbs, and I walked along side her with the glass, encouraging her to drink, as one coaches a mother in labor.

"Keep going, Kristi, you are doing well. Soon it will pass

and all will be over," I heard my voice say, not really knowing what to do.

She would stop for a sip of the herbal pain medication, and then keep pacing. Suddenly she went to the bathroom and passed an even bigger piece of tissue. And then the spasms were over.

Exhausted, I put her into bed, covering her with a soft down-filled quilt. I lay down beside her just as the early morning dawn was coming up on the horizon. We lay in a dazed quiet, trying to discern what had just happened. I did not know what to say or what to do.

Quietly Kristi began, "It has been so many months since Eugene had a wife. And the boys have not had a mother that can even hold them, much less help with their care. You, Mom, have taken so much time away from your own life and work. I can't keep expecting you to do that."

I was about to protest when she continued. "Eugene can marry again, he is very young. And my brother Chip will take the boys; he'll be a great dad. And the boys will always have you and Dad as their grandparents."

Her voice trailed off. She turned on her side, curling into fetal position and I could feel a coldness creeping into her body.

Oh dear God, I realized, Kristi has made the choice to die! And I cannot touch that choice because I promised I would help her. The despair that swept over me was one I have never experienced before or since. It was a total sense of grief and loss, a grief so deep that it held all the losses of all the generations of women and children in our family for all time. The sense of it was so profound that I could not breathe. I was paralyzed.

The void is black—silent—peaceful—quiet. When something is beyond tolerance, one is gracefully ushered into this space. Anesthesia and amnesia can be a gift. But then, life calls us back. We must return if we have made promises. When you return from the void there is a humming in your ears, a crushing in your chest, a raw burning pain searing through your lungs. And—you surrender.

Once there is no struggle—a flow returns. A stream of images, like a role of film being played before your eyes, informs you. You see everything at once—in Technicolor. And then you move over, and a subtle wisdom steps into you and speaks since you know not what to say.

Suddenly I heard a voice, which sounded like mine, say to her, "Kristi, you have the right to make any decision you want, it is your body and your life. But listen to what you are saying. You are measuring the value of your life based on what you *do* —for Eugene, the boy babies, for the rest of us. *That is the old way! That kind of thinking must die!* It is the curse of the women in our lineage that is being called to end with you and me. Life is really about what we *are*. Why do you think Ethan cries and hits? It's because he can't be with you. It has nothing to do with what you do or do not *do* for him; it is your presence he craves. The same is true for Eugene and all the rest of us."

She lay quiet, but I could tell she was listening, so I continued.

"Kristi, I cannot tell you how much I hate being in this space. I hate watching you suffer. I detest the sound of you crying quietly into your pillow when the pain gets too bad. It's so difficult to see your longing and depression when doing everything right ends with no improvement. And for a penny, I

would run away from here as far as I can go. But because it is so horrific, because I hate it so much, it is teaching me a lesson. I find that the more I don't want to be here, the closer to it I must come."

And with that I wrapped myself around her and started to stroke her hair as I had done so often in her childhood.

I then finished with, "If you leave, your children will experience the life of an orphan just like my mother and all those before her. I will love and care for your children, just as others took care of her. But I cannot and will not be a substitute for you. I will give my best, but no one can or will replace you."

Then I began to pray with intensity unknown to me until that moment. "Please, dear God, this is a humble mother pleading for mercy for her daughter."

Again and again I uttered the prayer out loud, holding my daughter close and gently stroking her hair.

Grandmother's Gift

In that moment I felt a great warmth wrapping around me, and I sensed the spirit of my grandmother. I realized that I was holding Kristi the way I held Grandmother as we said our goodbye before she left for Hospice care so many years earlier. Grandmother was embracing us all, and a deep sense of peace enveloped me in a most comforting way.

Kristi remained quiet and unmoving; her breathing grew slow and deliberate. I did not know if she was going to sleep or if she was releasing her life force. Exhausted, I fell into a deep sleep and dreamt of my grandmother and some of the many wonderful moments we had shared.

Suddenly I was awakened as Kristi stirred. Two hours had passed, and she awoke with a new resolve in her eye. Looking at her I could tell that Kristi had made the choice: She was going to stay and face this difficult time! A sense of deep exaltation flowed through my body and tears of gratitude streamed down my cheeks as I gave thanks and prayers of gratitude to the great God of the Universe. And so it was that Kristi began the long road to true and deep recovery.

The next day I got an e-mail from Wanigi Waci.

From: WW
To: JoEllen Koerner
Sent: Friday, July 28
Subject: Healing

She will heal and everything will be ok. The season of pain is unbearable and long, the belief system of oneself comes into question, and human cocreations of doubt, anger, frustration, resentment, and eventual disillusionment in oneself…then others. She will heal and everything will be good.

Pray, not for forgiveness but for LOVE of the WAKAN (Creator) to permeate Kris and her Spirit embracing the healing. What you carry in you at the deepest level she has as her guide for the meaning of wellness and directly affects her potential for health. You are a marvelous vehicle for healing and have inspired many, many people to regain a balance and honor within themselves. Jo, I KNOW it is very, very hard for Kristi and the pain is unbearable, but

in the end everything will be joyous.

We are on new ground working with your integral belief (collectively formalized in your present process of individuation). Our way of medicine involves the very essence of our beingness. SHE is HEALED already and healing is open for you also. WHO is really receiving the lesson in healing? Those we hold so dear and wish to take the pains of life for and suffer for, ARE in reality our teachers. We are able to walk through pain and endure for our loved ones but can we let our LOVED ONES walk through pain and endure? In our weakest moment is our strength. We can work very hard to make IT happen or open up and let IT happen in harmony with Universal Manifestation.

In my daughter's illness and her extreme pain I sit and honor the Creator, give daily thanks to the Spirits that let me know all will be OK and that her health will be regained, and work beyond my human-ness to accept healing as it grows in her. The con-sciousness of developing an attitude for healing in her mind that is beyond her pain, the ability to work with her body in its present state to embrace the ability to function beyond its present painful limitations. And constantly talking, singing, hold-ing, standing in silence in the agony of her pain, talking to the medicines in her and the specific parts of her body about welcoming the healing. And eventually making a commitment to willingly take some of her suffering by actively participating in

ceremony to overcome suffering through wounsila
(truthful open compassion for and with the rela-
tives) and humility. To be gratefully humble for
having the opportunity to be a part of this glorious
process. Like at Sundance, if your consciousness
moved beyond the pain and suffering, moved beyond
the prayer sticks around the arbor, into the Sacred
Circle, then you would be able to see the beautiful,
glorious, peaceful love that the other dancers and I
were standing in.

Just as Kristi is learning in the pain she is
also learning the peace of endurance and she can be
so strong that she can transcend the multigenera-
tional "FEAR" patterns of her predecessors!! This is
something that has taken form, now we are asking it
to dematerialize - first in the consciousness
(thought pattern) then physically and for resurgence
in the Spirit.

Our love and prayers are with you. H(harmonizing)
E(energies) A(addressing) L(limitations) I(identify-
ing) N(needs) G(growing) S(stronger). I can come
with more medicine for her, if you so choose. ALL
will be WELL. What healing is taking place for you?
Our girls will be dancing for joy shortly.
WW

From that point forward Kristi continued to improve. She
had several other appointments with the physician, but the left
stone remained. A very thoughtful and conservative surgeon,
he ultimately took her to outpatient surgery and broke up the

stone with lithotripsy. She passed the last stone in small pieces. A week later the last stent was removed, making Kristi stent-free for the first time in thirteen weeks. Her journey back to health was now unfolding!

I sent another note of gratitude to Wanigi Waci, expressing how different it felt to see Kristi on "the other side" of the stone experience, and how the long and arduous process had transformed my sense of being a mother and grandmother. He replied:

From: WW
To: JoEllen Koerner
Sent: Monday, July 31
Subject: Mothers/Daughters

WOWMOMWOWMOMWOWMOMWOWMOM!! The ate
(FatherCreatorConsciousness) holds the linear con-
cepts of forces that the human conceptualizes as
necessary to accomplish realities one manifests as
success and harmony. To make a sacred gesture to
qualify these accomplishments, the human makes ref-
erences to the vertical connections (earth,
heaven,hell, etc.). The ina
(MotherCreatorConsciousness) holds the circular con-
cepts of forces conceptualized as forming, develop-
ing, becoming in full potential, fragmenting, dissi-
pating, rebirthing. Both of these essences flow
through a greater consciousness and beingness called
WAKAN (SACRED). EARTH IS OUR MOTHER. All humans are
a wiyan oyate (female) for the first three moons,

conception to the end of the first trimester.

The two consciousnesses intertwine to harmonize this earth existence. The male consciousness(ATE) is forging ahead on a linear time line, quantifying and attempting to conquer everything, getting to the point of possessing everything (trying to achieve power by trying to figure out the Creation and possessing of things which make them Powerful…. as a god??). EVERYTHING YOU THINK YOU HAVE AND KNOW (material, intellectual, degrees) WILL STAY WITH THE EARTH ONCE YOU LEAVE! They belong to this existence and are great here. The second consciousness (INA) works with nurturing, forgiving (translations birthing/ deathing/separation/enjoining, etc.) forever moving in circles of beginnings and endings until she becomes Unica (GRANDmother). WHEN YOU SEE THAT THEY ARE THE SAME THING IN DIFFERENT WAYS the balance between these existences births a level of harmony.

When the male and female consciousness intersects there emerges the true harmonized potential for existence of conceptualized and birthed opportunities. In life the concept materializes in the physical manifestation of children. Overall these concepts are called imagination, dreams, thoughts, etc. The human existence is how one manifests realities of these thoughts, ideas, dreams, and how they are further materialized in others and the next generation of earthbound existences. If the male and female consciousness intertwines, a level of balance

can exist. There are two other counter sides to the
male and female consciousness called the femalemale
and the malefemale. That is why in working with
things sometimes it takes four times to materialize
it! Later. Have a wonder-full day!
WW

Kristi finally went home several days after having the final
stent removed. Seven months of bed rest had taken its toll, but
her joy and determination quickly found her rejoining the
rhythms of life she had known before the illness began. It was
two days after Kristi's last surgery that my mother was to expe-
rience the greatest life disruption she had known in fifty-four
years, and Wanigi Waci's prophecy was made manifest.

The Intergenerational Journey Towards Wholeness

My parents settled into the home of my childhood when I was two weeks old. The last trimester of mother's pregnancy had been busy as she and Dad remodeled an older home. They had moved onto land that had been given to them as a wedding gift by her parents. It was the only home I would ever know growing up as they lived there for their entire life together.

The little white house on the corner of Seventh and Dewald in Freeman, South Dakota, hosted a myriad of activities and adventures that formed the memories I cherish today. It was a favorite convening spot for the twenty-six children who filled our neighborhood with ball games, impromptu cir-

cuses and acrobatic feats of great daring. Cats and dogs were plentiful in this childhood oasis. It was also the place where I came to know the depth and power of "family."

We were not wealthy by community standards, but my ingenious parents were so creative that I thought I was the richest person on earth. Mother had a magical way of making one pound of hamburger into a feast for legions. She would take rejected, worn-out curtains and create dresses for any occasion for my sisters and me. Her generosity of spirit found her taking cakes and pies to neighbors during an illness, after a funeral, and just as a way to say, "I care." Those endearing qualities assured that there was plenty of traffic through the door of this humble abode.

My father was an unusual man in that he had a huge capacity for invention and ingenuity. He was forever designing and creating things to support his many hobbies and interests. The meager Christmas gifts would challenge the recipient to open them. One had to trip the mousetrap to get to the treasure inside without getting caught! On a cold and moon-filled Halloween night, he took us on a dried-out river-bottom walk, telling us the terrifying tale of the Headless Horsemen from The *Legend of Sleepy Hollow*. I was certain that I saw the ghostly figure galloping along side us on a path through the trees.

Within those walls our family lived out the drama of six people, each discovering life in our own particular ways. Births, deaths, calamities, and delights were shared as we grew up. As the last child left home, my parents took a month-long vacation to Alaska. In the solitude of that vast space they redesigned their life and lived as inseparable parts of one whole until my father's death. Mother never quite recovered from his loss.

Seven years after his passing, Mom started to show signs of failing health. It was time for her to move to another place, one she could manage more easily given her physical limitations. And so, two days after Kristi's last surgery, we moved her into a small apartment at the edge of town.

Mother's Healing Journey

Throughout the summer my sister, Bernette, and I gathered periodically at our childhood home to help Mom prepare for moving into a small efficiency apartment. I was not prepared for the depth of emotional tug felt as we helped her sort through fifty-four years of accumulated treasures, memories, and piles of "stuff." On moving day, her children and grandchildren descended with cars and pickup trucks. Within six hours she was safely transported into her new space. I decided to spend the first night with her so she would not have to listen to the new "night sounds" alone.

As darkness fell, I lay on the couch surveying the new place, trying to imagine what this must feel like for Mom. She had never experienced a move of this scale, and she had been required to leave so many treasured things behind. As I looked at the walls I noticed that she had put up some things that she never liked very much. I made a mental note to inquire about her selections the next day. Exhausted from Kristi's long recovery process and my mother's move, I fell into a deep sleep.

The next morning as we shared breakfast, I inquired, "Mom, I notice that you brought over some things that I know you didn't really cherish—things like that western picture on the wall."

At that we both chuckled, and she replied, "Well, that picture always went with the shelf under it."

Gently I said, "But Mom, there are other things that could go there now. This move is a time for you to really consider what you love most. Surround yourself with the things that thrill your heart. Let's spend today thinking about what you want to wrap around yourself in this warm and wonderful space." She nodded her agreement.

I went back to the home of my childhood, which was almost empty now. All furniture was gone, walls were bare, and a series of boxes marked "the kids" and "Salvation Army" stood in the living room. I sorted through her things, picking up some of her earlier wheat-weaving creations, crochet and knitting pieces, and treasures she had gathered on her travels with Dad. When the box was full I returned to the little apartment. Mom was sorting clothes in her new bedroom.

In her living room I replaced the western pictures with counted cross-stitch pictures and a wheat-weaving piece that she had made. The woven baskets on the shelf were replaced with fragile Hummel figurines. I draped the couch with one of her beautiful afghans and placed in a prominent spot her china teapot with the delicate rose handle. I put long-stemmed flowers in a clear glass bowl and set it on her piano, and on the low table in front of the window I placed the last picture taken of Dad and her. Surveying the room, it had the look and feel of my mother!

I called her into the room. When she surveyed the space she was literally dumbstruck. She sat down in her chair, surveying it all with a sense of wonder.

"Mom," I gently said. "*Look* at all the wonderful things you

have created, gathered, and loved through all these years. For all of your life you made room for Dad and his western art, and you've tolerated it so well. But now it is your time to define yourself by your deepest loves and desires. It is time for you to take this space and truly make it your own. Your eyes should fall on the treasures that have most joy and meaning for you."

Tears streamed down her cheeks as she started to move about the room. She commented on how her cherished possessions had never looked like this before. They had often been hidden in obscure spots of the house.

We then set about arranging the various rooms. Her sewing room held a corner of books and things that Dad had loved. He was still present in a tangible way, but those treasures were relegated to the one area of the house where she would spend most of her time. The kitchen was her favorite spot, and we set about dishes and pictures with great sentimental value.

When I asked what she wanted in her bedroom, she quickly said, "The family!" So I returned to the little house on Seventh and Dewald and gathered up multiple pictures of the children, grandchildren, and other family members. On the way out, my eye fell on a small picture of an older couple taken in the days of the still box camera. I picked it up and tucked it into the bag.

Mom was waiting eagerly. We quickly set up a picture gallery that surrounded her bed with the smiling faces of her parents, husband, children, and grandchildren, all showing the progression of growth and aging across her lifespan.

As we were finishing the work, I pulled out the small picture that had caught my eye and inquired, "Mom, who is this? I have seen this picture several times at your home, but always wondered who it was."

Mom picked up the picture, and almost reverently said, "This is the woman who took care of me when my mother died."

"Really, Mom? Would you mind telling me the story about her? It's one you have never spoken about. Let's stop and have some tea."

We sat in her newly designed living room sipping tea as she slowly shared the story with me. Four hours later I got up from a conversation that changed my understanding of my mother... and my Self.

"So, Mom," I asked again. "Who was this woman?" At eighty, my mother was still quick of wit, but some memories lie buried beneath the pain of her early childhood.

She started by saying, "I don't know, Jo, that was so long ago." I sat in silence, allowing one memory after another to surface.

Then she began speaking slowly and softly. "My mother died giving birth to me. She got some kind of infection and ten days later she was gone. Your grandfather had lost a daughter just two years earlier, and the grief of it was too much. He left and went to California. Since I was such a small baby, this woman, my grandmother, took me in. Her husband would get up in the middle of the night to milk a cow for warm milk to feed me. It was her loving care that kept me alive."

She went on to tell of her early years as "an orphan," moving from one aunt to another for prescribed periods of time. Goldie, her older sister, was her one constant companion in those early years. Three years after he left, her father returned and married one of his first wife's sisters. A dutiful marriage, there was not a lot of joy about it in her memories.

The conversation shifted to her "real mother," Caroline.

She knew so little about her as no one wanted to talk about her for fear of hurting the feelings of Mom's "second mother." I started to ask if it was hard being a woman in that era.

Suddenly she looked at me and said, "I have not told this to many people. When I was sixty-six, my mother's sister, Tante Freine (Aunt Francis), told me something that really hurt me. My nickname has always been Jimmy. My family told me it was because Dad had wanted to have a son. But when Tante Freine was dying she called me to her bedside and told me about my mother and my early life. I was really called Jimmy because when I was born there was a cartoon strip called 'Jimmy the Orphan.' They were referring to my being an orphan when they gave me that name!"

The devastation on her face was so painful that tears sprang into my eyes.

She continued her story. "And do you know what else she told me? My mother lived on the homestead, the place where so many of the family had been born. Grandpa was still alive and living with them, and so she constantly had relatives stopping by for dinner or supper. She had to host the Sunday gatherings and was always tied to the stove, cooking. She also got a lot of criticism from the rest of the family about how she kept up the house.

"The basement was a dugout underneath the house. It was the place they stored potatoes and carrots and other vegetables raise in the garden during the summer. Shortly before I was born, my mother was in the basement gathering up food to prepare for the larger family. She told Tante Freine that she lifted her hands skyward and said, 'Oh God, this life is too hard. Please let this house fall down and crush me. Take me home.'"

Great tears streamed down Mother's face. I remained quiet as she laid out her hurts, her fears, and her sense of deep loss over never having known her mother. And, most especially, the pain of her mother *choosing* to leave. In that moment, any hurt I held from her lack of availability to me melted in a moment of compassion and was replaced by the love I felt for this woman. It overwhelmed and filled every part of me.

I was able to show her the many ways in which she did *not* repeat that same experience with us. That was the time to tell her the story of the five stones and what the Medicine Man had said about our family. I pointed out that she chose *not* to die, but rather chose to struggle with birthing me. Her courage gave us a shared life.

I was *not* an orphan.

Then she said, "You know, Jo, when I thought of leaving my home, I realized that I would be losing the last thing I really treasure. I didn't know how I could possibly get through it. Then I started coming to your house to take care of JJ. When I saw how hard it was for Kristi and you, and how courageously Kristi was suffering, I realized I could do *anything*. It gave me the courage to go on. "

The sun was setting on the horizon as we picked up our empty teacups and walked back to the kitchen, a mother and daughter truly connected at the soul.

Great-Grandmother's Visit

The following week found me traveling once again. After four days on the road, I was on the last leg of my trip. Sitting in the Minneapolis airport I opened my e-mail to catch up on corre-

spondence. To my surprise I found a note from Eckhard Goerz, a distant relative. A year earlier I had given a presentation in Canada and was startled to see his name on the program.

As he finished his speech I rushed to him and said, "Where is the 't' in Goertz?"

He chuckled and said, "Oh, you must be one of the American Goerzs. They spell their name wrong!"

And thus began a conversation that led us to the discovery that we were close relatives, no small feat since there are less than 400 Goertzs known to be still living!

With great anticipation I opened his e-mail. What ancestral treasure had he found now?

```
From: Eckhard Goerz
To: JoEllen Koerner
Sent: Monday, August 21
Subject: A Letter
```

```
Dear JoEllen,
    In looking through things I just stumbled upon
this letter from a very interesting character. As I
reviewed the letter written by this man I thought of
our meaningful conversations about our common ances-
try and wanted to share it with you.
```

Eagerly I opened the e-mail to see what he had sent. I was dumbfounded to find a letter written by *my father* in 1976! It held the story of my great-great-grandmother's death at sea!

```
My grandfather's family was quite musical. Grandpa's
```

brother Henry wrote many songs. My grandfather and his brothers were all bearded. My father liked Smith Brother's cough drops because the bearded brothers reminded him of his father and his brothers. They would sing all night, switching parts around and taking turns singing base or tenor. Part of the tragedy of losing their mother on the ocean was the loss of her golden voice. They insisted that when my great-grandmother Katherina would sing, all others would stop their singing and listen. The entire group felt her loss because her voice was forever hushed.

There followed just a word or two about her death and burial at sea. My grandfather's older aunt Katherina, who was 13 years old at the time, wrote:

Mother cried and prayed much; she questioned if she would ever arrive in America. She insisted that she wouldn't and she soon became ill on the ship and died July 3, 1874 at the age of 36 years. She was sewed up in sailors cloth and tied to a steel plate and let down in the sea as we read in Rev. 20:13.

My grandfather had more details. He told the story from the morning of her death. She and everyone else in steerage knew the end was near so the other passengers took her children and left the grieving father alone with his wife. What they talked about was never revealed. Then the father summoned the first-born, John. The mother talked to him and sent for the

second child, daughter Katherina. After she gave her charge to the daughter, she summoned the third child. He says she told him what she would expect of him if she were to live and she that would expect no less when she was dead.

She then asked for baby Heinrich to be placed in her arms. After she fondled him a bit, she gave him to the father and told him what to tell the son when he got old enough to understand. Then she turned her face to the bulkhead and expired with her family at her side.

She was sewed into a sailcloth sack as Katherina wrote. But grandfather insisted it was a sack of coal and not a steel plate that was tied to her feet for ballast. The purpose of the weight was to make her sink quickly. Because these old ships traveled slowly the scavenger fish would follow to eat any garbage thrown overboard. The idea was to sink the dead humans below the depths where scavenger fish prey before the fish could devour them. After great-grandmother was prepared for burial she was put on the plank and it was balanced on the ships rail like a seesaw. After the committal service and prayer, the plank was tilted and the corpse was sent on its way. Grandpa's last memory was of the fish leaping out of the water and tearing at the canvas before it even hit the surface of the ocean. These are a few thoughts that come to mind as I ramble on.

> *Das ist aber jezt genung!*
> *Mit freundlichen Grussen*

Reuben Goertz

I sat in a stupor. My heart was pounding wildly at hearing my father speak through this letter. I had missed him so deeply many times during Kristi's crisis, and often called to him at night. Now his message came, and I had the true story of Great-Great-Grandmother's death in the midst of hardship crossing the sea. It was the story of "the last stone." All women had now surfaced in Kristi's healing event. Dazed, I flew back to South Dakota to share this message with Kristi.

The synchronicity of the moment was overwhelming and deeply healing. Now, I thought, this event has gone full circle. Little did I know that other dimensions of healing were still waiting to be revealed.

Finding My New Center

As I drove home from the airport my mind and heart were filled with awe and wonder at the entire unfolding sequence of events. The improbability of the activities that continued to transpire after Kristi's return to her own home and life overwhelmed me. As I drove into the yard of our condo, my headlights cast a beam onto the landscape I so dearly loved.

Dennis and I had chosen Valley Oaks for our retirement home. When a farmer/rancher has spent his life with green and growing things, he needs to be able to gaze out onto a place that is filled with life. We carefully selected this place because it sat on the edge of what was once a vibrant golf course. The valley in our back yard was rimmed with towering oak trees that thrilled us with their changing foliage all year long.

When we first moved into the space, I asked a gardener to plant a space for "the critters." We have an abundance of rabbits, squirrels, deer, and other four-legged creatures. Many types of birds as well as butterflies and bees happily hum in the abundant flowers and foliage.

Mother Nature Moves

Driving past my favorite oak tree, the one with the swing attached for the grandchildren, I thought I noticed something unusual at the top of the tree. The next morning I rushed outside to see it in daylight. To my dismay the tree appeared to be dying. The top third of the tree was withered, all of its leaves dead.

Wow! I thought to myself. It was perfectly healthy when I left five days ago. What could be happening? I quickly called the gardener (who had become a true friend) and he came around the next day. By then two-thirds of the tree was dead. He shared my concern and gently snipped a small branch off the tree. To his dismay the tree appeared to have a disease that would destroy not only that tree, but most possibly *all* of the oak trees in the area.

Heartsick, I asked what I could do.

"This is a very contagious disease," he said. "If it were spring and the sap was running up into the trees it would not be so devastating. However, it is the fall, and the sap is returning to the roots. This area's entire forest of oaks has a deeply entwined root system. The only thing we might do is cut a trench three feet deep along side this bank of trees, but there is no guarantee that any of them will survive."

He then called the county extension agent to come and survey the site for this disease that could well impact the entire region.

By the third morning the tree was dead, and a few of the neighboring trees had begun to exhibit dead branches. I wept at the loss of my beloved tree. It held so many happy memories with the grandchildren. Dennis and I have a special love for trees. Throughout the years we have planted hundreds of trees in shelterbelts for the animals living on the farm. Trees were like a second family to me.

As I was pondering what to do, Wanigi Waci called. After we discussed the issues of the day, I said, "Wanigi Waci, I do not mean to complain, but my trees, my precious trees, are dying. *What* can I do about it?"

He was silent a moment and then asked why it was so troubling. "Are you worried about the economic value of your land if the trees die?"

Quickly I responded, "No, I am just feeling such a deep loss. I love those trees."

Wanigi Waci talked about our Western view of control; how when things didn't go the way we wanted we would step in and try to manipulate the outcome. Maybe the trees had completed their life cycle and it was time to dematerialize so they could continue their evolutionary journey. One choice would be to dig the trenches, call in the tree specialists, and try to stop further decimation. A second way would be to honor the natural flow of things, both in nature and our own life. Had I not just gone through a deep life experience in which some things came to an end so that new ones could emerge? He suggested that trees are living things, and if I chose to

honor nature's rhythms a ceremony of appreciation would be in order.

Later that day I received the following response to an e-mail I sent inquiring about such ceremony:

From: WW
To: JoEllen Koerner
Sent: Wednesday, August 30
Subject: Trees

Prayers and their meanings are in direct proportion to heart intent. (Jo to tree), "Why are you leaving? Why are you dying?" (Tree to Jo), "We are still here and will continue to hold the resonance in the immaterial world for fifty years or more...or less as we have in the material world. Time is a construct of your will. The real question is, "Jo human, why are you leaving us in your mind? Expand your consciousness and it will all work out in the end, or was it the beginning? Us trees tend to get confused sometimes about what an end and a beginning are, silly of us!" Do a sacred ceremony; it is essential to manifesting meaning in the space-time of understanding things we hold as real. Test the soil, find the compatibilities, and replant accordingly...AND have fun!!!
WW

I thought much about the issue of control versus flow and realized that in some ways members of my family had been

disturbed by the way Kristi and I wove indigenous and Western healing together. Had we stayed only in the Western traditions I would not have come to know the spiritual meanings of this illness. What transpired would have been very different. If I had claimed the right to grow, change, and evolve, so should that right be extended to every living thing. I went outside and performed a small sacred ceremony of gratitude to the tree and the entire little forest that surrounds our place.

The next morning I awoke early, eager to see what was happening to the trees. To my total amazement I could not see out. Darkness covered the entire kitchen window. Upon closer examination I saw that it was covered with thousands of tiny winged creatures that were crawling and swarming on the glass. I ran to the door, and as I threw it open, hundreds flew into the house.

Quickly I slammed it shut, and stood in total amazement. *What* was this? I went out the back door and found the entire south side of the house engulfed with these creatures.

At that moment the phone rang. It was Wanigi Waci. We talked about the things of the day, and then I said once again, "Wanigi Waci, I do not mean to complain, but the most bizarre thing is happening. My house is inundated with thousands, maybe millions, of small winged creatures that are swarming around. I don't know what to do!"

A light chuckle came from the other end of the phone. "Jo, you live at the edge of a golf course. Think of all the pesticides and other toxic chemicals sprayed throughout the years to get the effect of beauty in that space. How many times did excessive watering of the greens lower the water table? Think of the number of ways that nature was manipulated and controlled by man to create the desired effect."

In my mind's eye I could see the pest control programs and watering patterns that had been such a large part of its history as a golf course.

Wanigi Waci went on. "You have just gone through a healing at the deep belief level, down at the genetic and ancestral level. *Everything* is changing within you. Since everything is interconnected, everything around you also will change. The exterior manifests the interior. All things are seeking new balance, a new center."

I stood transfixed, not knowing what to say as the bugs kept swarming in my view.

"You have several choices, just like with the trees. You could control them and call an exterminator who would spray them and suppress them back into control. It would work for awhile at least."

I quickly protested saying I knew that was not the answer. However, I could not allow the bugs to totally destroy the very foundation of my home.

Wanigi Waci had an alternative suggestion. "Do you have a place that they could move to? Is there a hospitable place for them to live?"

Quickly I replied, "Oh yes, we have planted a spot just for the critters!"

"Well then, why don't you invite them to live there?"

I thought for a few moments, and never having spoken to bugs before I started to laugh. "Wanigi Waci, *how* do you invite bugs to another space?"

He said, "It's time for you to start using your intuition instead of always seeking answers from me. What do bugs and

ants like? They like sweet things. Could you offer them something sweet as an enticement?"

The next thing I knew, I found myself mixing a large bottle of sugar water, and then I carefully slid out of the house through a side door. I walked the full length of the south side of the house that was teaming with the creatures, pouring a trail of sweet water as I went along. I invited them to relocate to a place that was more hospitable to them and asked them to please leave the house alone. I let them know that there was plenty of space for all of us, but that we each had a unique place to dwell. I laced the majority of the sweet liquid among the trees and bushes we had intentionally planted for wildlife.

I went back into the house and busied myself with other things. Several hours later I returned outside and not a single bug was left near the house. The natural space we had reserved for critters was teaming with little creatures setting up housekeeping. When I returned to the house I discovered the foundation had shifted so much that there were large cracks in basement walls inside the house. The concrete patio that wrapped around the house had been broken in several places. The house had literally been shifted on its foundation! But I never saw another creature on the side of the house. They had truly moved into another space. The following spring the "dead" tree and all of its neighbors returned and bloomed in perfect health; they have remained so to this day.

Henblachyea—A Vision Quest

Kristi's health continued to improve. She returned to work part-time. Little JJ moved from being totally colic to having sporadic angelic moments. He passed the charm test, and day care became his day job. A sense of order and rhythm began to appear in our previously chaotic world.

I, however, was in a state of total disorientation. While all of the things I held to be true still were so, I had been awakened to other dimensions of truth that were operating simultaneously.

At this time the dot.com world was coming apart, just like every other aspect of my life. At the company where I was working, we had progressed on creating the framework and course outlines for an international nursing academy, but the funds were quickly drying up. An industry that had once known such abundance was suddenly withering. This caused everyone and everything associated with it to shift the focus from mission to bottom line. We became embroiled in the merger-mania sweeping the field, and suddenly, someone else acquired controlling interest in our company. Everyone and everything was up for grabs.

I felt like a split personality. During the day I would continue functioning as the chief nursing officer at work, spending much of my time at home on the Internet. But I found that night was my favorite time. Each morning at 3:00 A.M., I would awaken, and in the sacred silence of the night, I was able to take out precious memories of recent events and sort through them, trying to make sense of their meaning in relation to the worldview that had served me so well for so long.

One day the phone rang. It was Wanigi Waci inviting me to meet him for lunch. I drove to the restaurant with a mounting sense of anticipation.

As we finished our meal, he said, "Now it is time for you to go on the hill and give back to the great Creator. Kristi lived because of your fervent prayers, and so you must now give something back."

For a very long time I had wanted to go on the hill but knew I was not ready for a *Henblachyea*, or Vision Quest. The thought of this opportunity was both exciting and terrifying. What if I could not stay on the hill, do without food and water, face fears that would overwhelm me, receive a message that might destroy me? A host of thoughts rushed through my mind, but I heard a calm voice coming from somewhere say, "Thank you for the privilege, Wanigi Waci. I am most honored to go on the hill to fast and pray for all the People." I asked if my friend Liz could also join me, and he quickly agreed.

Even the preparation for a Vision Quest was a major event. I once again made 405 prayer ties along with six spirit flags, but this time the focus and intent of the prayers were different. This time it was about gratitude and surrender—it was preparing me to go back into "The Void."

Liz and I first met when Wanigi Waci's work began at Sioux Valley Hospital. She was an osteopath working with reservation-based Natives suffering from diabetes. Her conservative treatment measures, coupled with macrobiotic diet, had saved literally hundreds of extremities from amputation. Liz's sense of humor was matched by a wild energy that defied conventional wisdom, often when common sense dictated a different course.

Like me, she was walking between two worlds and finding the clash of healing cultures to be confounding. In sisterhood, we had done many ceremonies together through the years.

She came to the condo the evening before the *Henblachyea* was to be held. Talking late into the night, we shared hopes and fears about the upcoming event. It was mid-September and the evenings could become quite cold. We both wondered if we would be warm enough—especially if it rained.

We arose at dawn, creating our ties as the sun rose in the east. These moments of sharing and communion were profound. We also sorted through the variety of materials required for the event, including a star quilt that came as a gift from one of the tribal elders.

Four Inipi sweat lodge ceremonies had to be performed as part of the preparation. During the four days prior to the Quest I had a sense of needing to put things in order. I found a strange pattern to the e-mails I was getting and sending. I received a note from a high school classmate, seeking forgiveness for the rude manner in which she had treated me. Folks appeared out of my distant past with messages and thoughts that were heartwarming or thought provoking. In my dreams I would see places I'd been and people I knew with whom I needed to follow up with a message the next day. By the time the appointed moment arrived I felt very centered and grateful to be going to a sacred place to say, *"Wopila," "Danke Schön,"* "Thank you" to the great healing Creator.

The last message I got on my e-mail system came from Wanigi Waci.

From: WW
To: JoEllen Koerner
Sent: Thursday, August 31
Subject: Ich bin auf der Welt zu allein und doch
nicht allein genug

Jo, please answer your CELL phone, God is call-
ing!! For too many there has been busy signals or
call waiting with "I'll call you back as soon as I'm
done" answers. Look within!

The macrocosm is reflective of the microcosm,
therein is the power—Universal Consciousness and not
just mind power. The first is the total essence of
the self within all of life throughout eternities.
The later is the figuring abilities to "master" this
existence! "Simple, but it's true, spirits are all
around you, but you have to do your part! All you
have to do is open up your heart" (Michael) thanks,
WW

I packed up my things and drove to Vermillion, meeting Liz
for our last lunch before beginning the long fast. We joked
nervously as we poked at the food, both wondering if we could
successfully complete the Vision Quest. Half an hour before it
was scheduled to start, we drove to the sacred grounds and set
up a small tent. We provided drinks and food for the people
who would watch and pray while we fasted on the hill.

Finally it was time to start. We put on the ceremonial dress-
es and walked to the waiting Wase Wapka Community members.

Liz and I were joined by another Wase Wapka community

member and two women from Iowa who had been working with another Spiritual Counselor. It was 6:00 P.M., the time just before sunset. I remember the deep stillness of the moment. Nature provided a magnificent canopy, a perfect wide blue South Dakota sky dotted with white fluffy clouds graced with a sun that was starting to slip into the western horizon. A flock of black birds flew over the group of twenty-five community members who had come to support us. They were gathered around the fire pit where the rocks were being heated for the ceremony. The ceremonial pipes and ties we had prepared were resting on an altar placed beneath the cottonwood "tree of life" that held vigilance to the entrance of the Inipi Lodge.

A Vision Quest is a time outside of time. Prayerful preparation is essential prior to going on the hill. After we donned our ceremonial dress, we walked in silence to the Inipi Lodge and joined the community. Wanigi Waci took our prayer ties, spirit flags, and all the other spiritual materials we had prepared and disappeared down the hill. He was creating individual altars and prayer space at isolated spots on the hill where each of us would experience our Vision Quest alone. The Spirits would determine the length of time for each individual. When Wanigi Waci returned, the ceremony began.

All of us "Seekers" waited by the fire ring until it was our turn. Each of us individually experienced the initiating ceremony and then were escorted to the hill. An initiating Inipi ceremony cleanses the body in preparation for going into a sacred space. Wanigi Waci, along with the singers and drummers, entered first.

My helpers were two women of the tribe who had agreed

to support me during the Vision Quest. They escorted me to the door of the Inipi Sweat Lodge. All of the community members were gathered outside the lodge, and each gave a farewell greeting. Some had special prayers they wanted me to say for loved ones while I was on the hill. With all the prayers and good wishes ringing in my ears and my heart, I slowly entered the lodge for one last prayer session. Then each community member slowly crawled, with humility, on bended knee, into the low-hanging lodge.

When the prayers ended I was wrapped in the star quilt. No one was to see my face until I returned from the hill and was cleansed once more in an Inipi ceremony. For all practical purposes, I was now dead to the physical world.

As I left the lodge, all I could see were my bare feet. The strong arms of my two helpers guided me down a path to where my prayer circle had been set up by Wanigi Waci. The entire tribal community had left the lodge to accompany me down the hill, with the sounds of their drumming and chanting as my companions. When they got close to the prayer site, they all turned their backs, and Wanigi Waci took me the rest of the way to the circle created by my prayer flags. I stood before him, covered with the blanket. Then he gently removed it and gave me instructions for the time I was to be on the hill.

As he left he smiled and said, "Jo, *listen* to the voice of God, and pray; pray hard for the People."

And with that he was gone. I was alone on a hillside with a star quilt, matches, and a sleeping bag.

At first I tried to get oriented, inspecting the area within the circle. It was large enough to lie down in. I was allowed to leave via the black ties only to go to the bathroom. Otherwise,

for my spiritual safety, I was not to venture outside the circle. When one is on a Vision Quest, one's spirit literally moves into another dimension. As long as it is held within the sacred circle it is energetically protected.

Inside the circle, standing in each of the four sacred directions (West, North, East, South) was a spirit flag mounted on a cherry tree branch. When I looked West, I was facing a long stretch of prairie with a creek surrounded by trees running through it. Freshly worked soil showed the signs of a recent harvest. A black spirit flag was mounted on the cherry branch. For the Sioux, West represents renewal and purification, and dispenses cleansing water and thunder.

Looking North was a small expanse of rolling hillside. Since it was fall, the landscape was brown, with a few remaining varieties of prairie grass holding on to the last signs of green summer. A red spirit flag was placed in that sacred direction. North represents procreation, health, and control.

The view to the East revealed the rest of the hill I was on. A yellow spirit flag dispenses thanksgiving, wisdom, and understanding. As I viewed the hill, I could see a path worn in the long grass, created by Seekers of many persuasions who had been on Vision Quests throughout the summer and into the fall. Wanigi Waci would offer such services to people from literally all over the world. He has always said that it is time to become a "whole people," that the circle must be inclusive, not exclusive. He lives his beliefs fully.

The backside of my hill created the exposure to the South. At the edge of circle was a white spirit flag. South dispenses rebirth and is the source of renewed life and destiny. Directly in front of the spirit flag was a circle made of finely sieved fresh

dirt from a badger hole. In it Wanigi Waci had drawn sacred symbols that I did not recognize. Sage was scattered around the circle, and we were encouraged to burn it as we prayed.

I went from one sacred direction to the other. Again and again I made the rounds (thinking of the many times I made "rounds" at the hospital as a nurse). First praying for all the People, then praying the specific prayers community members had asked me to take to the hill. Then I prayed for my family, both personal and professional, and last, I prayed for my Self. I prayed until I was so exhausted that I climbed into the sleeping bag and fell asleep.

Suddenly I was awakened and became aware of a very bright light. I quickly jumped out of the sleeping bag, thinking I had overslept and missed the sunrise. I had so badly wanted to greet the sun on my first full day on the hill. As I got oriented I saw that it was not the sun, but rather a brilliance coming directly from the south. Intuitively I knew that it was where Liz was praying, and I quickly got on my knees and sent prayers her way. Later she would tell me that she awoke and got so frightened that she prayed for me to come to her. She literally saw my body enter her prayer circle, keeping her company as she oriented herself to this unusual circumstance.

My first full day on the hill began at sunrise. For the entire forty-eight hours that we were on the hill, members of the Community took turns keeping a fire lit, singing songs, and offering prayers on our behalf. Wanigi Waci would later tell me that it was done to keep our energetic pattern alive in the universe so that we could return when the Vision Quest ended. Periodically the sweet sounds of drums and songs would float by. But most of the time there was only silence.

Throughout the day I would make a circle around the prayer stations, burning sage, and offering petitions for those I loved and all the People. Then I would move to the center of the circle, offer prayers of deep gratitude, letting my mind drift. By the end of the first day the notion of time and space was altered. The silence was so profound I could feel it pulsing in my ears. Tiny, subtle things came into sharp focus. I began to see the smallest details in a blade of grass. Colors became vibrant and alive, as though a fresh spring rain had washed the whole earth. I entertained frequent butterfly visitors. The million hues of blue in the sky literally danced before my eyes. The clouds in the sky outdid themselves in shifting shapes and images as they played hide-and-seek with the sun. And when a little cloudburst appeared in the valley below I could smell from a great distance the sweet scent of approaching rain.

When one does not eat, the body slows down. Hunger and thirst disappear. With no-thing to do and nowhere to go things begin to get quiet, deeply quiet. As evening began to descend an exquisite colorful sunset graced the sky. It was during this time that I made my usual rounds to the prayer stations except with an unusual twist. As I got to the first station, I suddenly had the sense of a voice asking me what I was seeking.

"I am trying to understand what has happened in my life. I am seeking to know the essence of things so that I can truly forgive all oppression in the world, especially my own."

Buried deep in my heart were Wanigi Waci's words to me that fateful day in the kitchen when he told us of the Oglala Medicine Man's image of my ancestors and the meaning of the five stones.

A kind voice asked, "Are you seeking to understand for the purpose of retribution or reconciliation?"

Without a moment's hesitation came the reply from deep inside me. "It is for reconciliation. Only in that way does life hold a future."

I sat in a dazed silence. Was I hallucinating? It was a voice, yet voiceless. I "saw" but not in the sense of material objects. It was more like an energetic knowing. The next thing I knew I found myself at the opening of a cave. I was handed a candle to illuminate the darkness, and slowly I wandered inside. As my eyes adjusted to the dark I saw multiple tunnels, all dusty and dark. Off to my right was one tunnel that was bright pink and moist, looking somewhat like a healthy blood vessel. I quickly turned in that direction and made my way down a long and slippery corridor.

When I got to the opening I was shocked and delighted to see my female ancestors sitting around the table. There were my great-grandmother, my grandmother, and a host of other women in the dark clothing worn by Mennonite women of that era. I wanted to run inside and hug my grandmother but was restrained from doing so.

As I watched, what had been a sense of joy turned into a deep sadness as I realized what I was witnessing. "Oh!" I cried aloud. "*How* can this be? It is the women who are placing fear into the hearts of the children. It is the women who are harshly punishing the children! How can this be?"

I was watching the young children sitting at the table, being told dreadful stories like the ones I was raised with; stories about a bear biting off the heads of children who laughed at old people. They were warned that hellfire was

theirs if they entertained any unkind thoughts. The list of "do's and don'ts" was long, and utterly impossible for a child with a curious mind and a pioneering spirit to absorb. With deep sadness I realized that while I loved my grandmothers so, they were the ones who had planted such deep fears in my own soul.

Despondent, I was searching for answers when the scene shifted. I suddenly saw the floor above them. It held a similar large round table, and surrounding it were my grandfather and the men of my ancestral heritage. I watched in amazement as they made rule after rule. Each time there was agreement they would shout, *"Done!"* slamming their fists on the table and stomping their feet. As they did this, a large tuning fork moved between the floors and began to resonate deeply. I saw the energy of the resonance encircle and trap the women and children in a circle of fear.

Once again I inquired of my guide, *"Why* do they do this? I know they loved us. So why would they do this?"

I was next shown the space above the men. In it sat their image of God. He was huge with a big flowing beard and a set of rules engraved on tablets. He was a God of wrath and vengeance and He was putting terror into the hearts of the men, who in our culture had total responsibility for raising and "ruling" a family. In that split second I "saw" that the root of all oppression in my culture was its underlying notion of God and His love. It defined and dictated the interpretation and expression of love, permeated every thing my people thought or did. Stunned, I stood back viewing the three dimensions moving simultaneously in an orchestrated fashion. As this realization moved through me, I cried out, *"WHAT IS THE ANSWER?*

How can we move beyond this? How does one live in a world of such oppression and fear?"

And then a still, small voice whispered so quietly that I had to hold my breath to hear it. "Live authentically" was the soft and simple answer.

At that moment my gaze was directed back to the ground floor where the women and children were housed. I saw a small girl off to the corner. She was by herself, just outside the reach of the band of fear that held the others hostage. Quietly playing with a small doll, she was singing a lullaby. I felt the sweet tenderness of her pure and innocent love. Waves of it moved towards the group bound by fear. As it tapped the rim of the circle, a tiny pinhole pierced its edge and slowly moved into the circle. Other small children saw the light and began to move towards the young girl. Slowly the circle began to enlarge, the edge softening and becoming porous. The older women also began to release their hold, and gradually the whole scene shifted to one of joy, of laughter, of unconditional love.

I quickly found myself being whisked to another space. Once again the opening found me gazing in on a scene of women, nurses ministering to patients. At first I was so delighted to see my professional family. But as I looked more closely, I saw that it was the nurses who hurt the patients. They were the ones giving shots, inserting harsh tubes into body orifices, and giving medications that made people violently ill.

Dazed I cried, "Why, we do the same thing to our patients that women do to our children! How can that be?"

As I gazed up I saw on the second floor a table filled with administrators and doctors who were making all the rules, writing the orders, giving the commands the nurses would

dutifully carry out. As I looked higher I saw the God of Science sitting with the irrefutable *Laws of Science and Economics*. At that moment I understood that the oppression within the healing fields was based on people's definition of healing and administration.

The waves kept going on and on until I saw the oppression of the universe. A song of authenticity and love played in my heart, and a deep sense of forgiveness to all—including myself—flooded my soul.

Dazed, I found that during that time I had moved through all four stations and went back to the center to try and take in everything I had heard and seen. I lay there in the dark, not knowing what time it was, but I knew it was well after midnight. Suddenly I heard a rustling in the grass and became alarmed. I looked up to see Wanigi Waci and his young son smudging the circle, which was my home, praying for safety and clarity.

He asked, "How are you doing, Jo?"

I was so full of wonder all I could do was exclaim, "It is such a miracle!"

He admonished me, "Keep praying, pray for the People. Let God speak to your higher consciousness. Listen to Him." He moved silently down the hill and was gone.

I lay in the dark watching the shooting stars, saw the planets twinkle with clarity unseen where modern lights mute the power of total darkness. Then I heard a voice. It was Wanigi Waci's. He stood on top of the hill and sang one of his ancient healing songs. At that moment I felt my heart burst open. The sense of joy that overcame me that moment is unlike anything experienced before or since in my life. It was as though the song sang me.

I suddenly saw a black book, with effervescent green ink, written in a language I could not read. A hand slowly wrote on the open page, and then the book disappeared. Later Wanigi Waci would tell me that we are beings of sound and vibration. It takes sound to transform us at a deep cellular level. I literally broke apart and came together again in a reconfigured form through the power of his loving song to the Creator.

The next morning, as the sun came up, it felt as though my skin had been peeled off and a raw, new one was beginning to wrap around me. In a sense of timelessness, the vision of an apple appeared. I could taste the flavor of it, hearing the crisp crunch as its skin is broken. I realized for the first time that I had been without food or water for more than two days. Suddenly I heard the drums. I heard the chants. I knew that the people were coming to get us. One by one they gathered us up and took us home.

My sense of joy knew no bounds! I leaped up with a happiness that fairly bubbled up from deep within. Much as a patient who recovers from cancer, I realized I had another chance to reenter the world and be a more loving and forgiving force within it. Never again would I judge so harshly the ways of anyone, not even my Self. We all live out of a cosmology that we inherit from people who are giving us the *best* they can, given what they have experienced and been taught in their own lives. Basically all people have a wonderful core essence, which is the essence of the Creator. When we keep that in sight, all else is possible.

Quickly I scrambled to my feet, covered myself completely with the star quilt, moved to a patch of sage, and waited for my escort back to life. I saw the feet of my two helpers who gently

put shoes on my feet. They took my arms and guided me back to the waiting caravan of community members who drummed, sang, and chanted as we walked back to the Inipi lodge. I was escorted inside and was slowly joined by the community. When all were seated, the heated stones were brought in and the door was sealed. In the warmth and darkness of the lodge we were allowed to take off the blankets. We had returned home!

Each of us was given a dipper of water, our first in three days. I wanted it so badly I could just smell and taste it. Instead, I poured the water on the rocks in memory of the women of my ancestry who had lived such harsh and parched lives. When the second round came, I took the dipper gratefully and sipped it, pouring most of it on my head in a cool baptismal rite.

Then we each were invited to tell our story, sharing what we saw and what we learned on the hill. The community members made wonderful sounds of encouragement, "Ahhhhh, ohhhh, and ho!" and shed tears with us as we wept. The ceremony of storytelling and listening with such sincere intent was a powerful healing in and of itself. After the ceremony was complete we were escorted outside for a welcoming feast.

As I stepped outside, the cool air rushed to greet me. I saw the beauty of the sky, the splendor of the nature scene, the smiling faces of my dear community members, and suddenly I fainted. When I came to I was lying on the ground, cool water being poured on my head. Later Wanigi Waci would share with me that my fainting meant that I did not want to return. He was right. The exquisite beauty of the moment on the hill, the silence, the love I felt, the clarity with which all things could be

seen and understood, made it hard to reenter the harsher world of my daily life.

After a feast in which we thanked the people who had so faithfully offered support during our time on the hill, I bade good-bye to my dear friend Liz and returned home. It was on the way home that I noticed for the first time the deep blistering of my lips from those days unprotected in the sun. I was also covered with mosquito bites that took several weeks to heal. At first only small bits of food and water were appealing. After several days I was back in full swing, but now I was coming from another place.

I wrote Wanigi Waci a note of thank you for the unselfish loving gift his community and he had provided. He responded with the following message:

From: WW
To: JoEllen Koerner
Sent: Tuesday
Subject: Danke Schoen

Jo,
 Wopila for completing your powerful demonstration of love for your daughter, children, grandchildren, and fasting soulmates (Roxi, Liz, and the sister from Iowa). They gave you purpose and you gave them your courage born of love to face fear and dissolve it into what it is, a thought pattern with a lot of value placed upon it by many around you. Especially the one soul who chose to walk with you in life! Control is a key ingredient to manifesting fear and

over a period of time is expressed as privilege. That's when the shoulds, thou musts, etc. are used to tie their concept of sacredness into the process. Their sense of God becomes an oppressor-colonizer, punisher and is to be FEARED! In other words, they have humanized their God into their own images of humanness from extreme love to cruel hate through damnation. Never realizing that the Creator is constant and it is only they that are fluctuating between these two extremes.

Your book is the book of life before and after this earth time. Creator says that as a "partner" with the Creator in Creation, the chains of fear are being broken. You are learning to "live" while you are here "alive" to this earth consciousness!

Transitions are natural; change is a part of life, everything and everyone is forever evolving at realities in realms of consciousness many times beyond comprehension. Therefore we place ourselves in dream states or vision states to absorb some of this knowledge! The environment around you reflects what is happening within! The more you try to control your yard, focusing in upon the trees, it seems like they are dying! Sadness, alarm, concern for, etc. arises. You have to DO SOMETHING to CONTROL the environment! The more you are attempting to be, some one is alarmed, concerned for, etc. about you seeming to be dying to their reality and you may have to be controlled in some way. All realities are being transformed!

Are the trees truly dying or transcending a pattern? Are the molecules with the subatomic structures making new partnerships based upon ancient knowingness to rearrange and remanifest in another form of creation? To thy own self be true for at the core of you is the Godness and Goodness of the Original Essence from the Original Source! May the Peace you are be the piece of love someone needs!!
Shalom,
Wanigi Waci

Several weeks after the Vision Quest, Liz and I offered a *Wopila* (Thank You) Feast and a Give-Away at the Native Cultural Center at the University of South Dakota in Vermillion. Kristi and the boys were also present. It was a wonderful evening of food and fellowship. We gave gifts to each precious community member with deep gratitude for the gifts they had so lovingly bestowed upon us. With tears and a grateful heart, I introduced Kristi, Ethan, and little JJ to those people who had prayed for them so often. I was able to end with the comment that these children would *not* know the life of an orphan, in part, because of the community's loving support. There were no dry eyes in the room.

Several days later I received the following from Wanigi Waci:

From: WW
To: JoEllen Koerner
Sent: Tuesday, September 19
Subject: Re: Sunday

Jo,

Thank you for the gifts! Many times I know what
it is like for the Buddhist monks to hold their bowl
out and if someone gives them even a grain of rice
how eternally grateful they are. The gesture in
receiving is so humbling. Just to think that someone
would stop to give of himself or herself so freely
with a true intention of letting go of something for
your benefit is so overpowering! It teaches of the
beauty within and its reflection has returned of free
will, making a circle and rebirthing once again in
the universe—the potential of MANifestation and
WOMANifestations! The Godness and Goodness ever-liv-
ing and unfolding within our consciousness to become
matters of life! Wopila for the wonder full gifts.
My family and I shall live because of your kindness
to us.
Wanigi Waci

A circle of loving and healing had been completed. My
sense of relationship had been enlarged through the loving
experience of the Wase Wapka community. Nothing was the
same, while everything was just as before. The experience of
healing at such a deep level gave me a deepened sense of
appreciation for all the people whom I had the privilege to wit-
ness in their own healing journey during my nursing career.
Many dear faces danced through my memory, and I realized
that we were all one.

Expressions of Gratitude
Wopila, Danke Schön

A few years have passed since this story took place. Life has returned to a sense of ordered chaos, as modern life is prone to do. Kristi is still recovering, but her spirits are high and her outlook on life is breathtaking. She and Eugene parent with a "sense of presence" to their children that is inspiring. Ethan has adjusted to his little brother, realizing that JJ will not go away; nor is he a temporary visitor! In fact, the two have become fast friends. Little Joshua Joseph is a force to be reckoned with. A strong-willed and beautiful little boy, he has outgrown colic and moved into the "charming" stage. Life at the Welch household has become more tranquil and

steady, at least as much as it can with two small children!

Dennis and I have reconnected at a deeper level as the entire episode showed us once more what is really important in life: The love of family and friends. While we had very different experiences throughout the long ordeal, we arrived at a shared space in the end because of deep and sometimes painful conversations along the way.

Looking back on the adventure with Kristi, I find that I have learned how to receive as well as to give. It is very humbling to seek help and to receive it graciously. That simple act opens up a deeper definition of community. The grace of simple gestures of kindness heals more deeply than the most exalted measures of technology. A balance is needed in all things to acquire the whole. I have returned to my nursing world that is deeply embedded in science. And yet, I *know* that it is only part of the equation for healing. Love, intention, spiritual blessing, prayer; all of these are ingredients more powerful than antibiotics and surgery.

This experience has heightened my commitment to the caring agenda in nursing which is really a call to having an authentic presence that honors the life and values of the person being served. It is my deepest wish that anyone facing a health crisis could have access to not only superb medical care, but also the powerful guidance of spiritual healers such as Wanigi Waci. By blending the two worlds together, a balanced approach to healing is attained.

Wanigi Waci and I continue to work with various business and professional groups, sharing stories of the power of healing between two worlds. We are planning the Good Road Training & Indigenous Resource Center in Sioux Falls, South

Dakota. This center is being dedicated to the integration of healing modalities between indigenous healers, alternative healing arts practitioners, and Western medical practitioners. Our first project is focused on research identifying the correlation between diet, diabetes, and chemical dependency. Three health summits will bring together Western physicians, Native American medicine men, and holistic healers to create an integrated treatment plan for American Indians. Once this knowledge is placed on an Internet-based "tracker," it will blend the best of multiple healing modalities to achieve optimal well-being by honoring the unique Sioux culture and beliefs as the foundation for their care.

Cross-cultural and diversity integration processes for business and healing centers will also be available to help create more open and humane work environments. Personal growth and psychosocial trauma processing, based on indigenous beliefs, is being offered to professionals seeking ways to enhance their efficacy with multicultural clients and communities. And intergenerational coaching sessions will be there for seekers of a more integrated life within their family of origin. The center will also offer indigenous healing information, resources, and educational materials to facilitate the integration of these healing ways into other community-based activities. Whether Western medical practitioners acknowledge it or not, indigenous healers and other alternative providers are working with many of their patients. It is imperative that integration between these worlds occurs if a more effective health care delivery system is to be achieved.

One day Wanigi Waci asked me, "How's it going, Jo?"

I looked at him and said, "You know, I really don't feel like

I fit anywhere. It sort of feels like I am a witness to what is happening in life, but not really a part of any world."

He just chuckled and said, "Good! When you 'fit' that means you are molding into someone else's definition of what should be."

"Well then," I prodded, "what is the alternative?"

He looked at me with those large brown eyes twinkling and simply said, "Just BE. When you are BE-ing yourself you will attract other like-minded BE-ings and co-create something new together. Just stay awake, and you will recognize it when it happens."

And that is exactly what is occurring! I continue to meet wonderful people who share similar stories and aspirations. As I move through the world I am experiencing a heightened awareness of the multidimensionality of the reality in which we live. My profound journey with Kristi and my mother have underscored the fact that life is really a spiritual odyssey wrapped in a sojourn on this beautiful earth. Everything is deeply connected intergenerationally; what happens to one generation affects generations that follow. We must therefore be good stewards with the life we are given.

I continue to find myself deeply challenged to integrate this entire experience into my worldview. The essence of the event has gone beyond my understanding of both religion and science. Centuries ago Saint Augustine struggled to find an answer to the issue of our true spiritual nature. He observed:

> The personhood of man, therefore, is an inter-involve-ment of rich inter-communication or dialogue. Man, though he feels lonely, is always in encounter with

himSelf. The more he presses this dialogue of the self, the deeper he goes into the Self itself. Sooner or later he encounters the Totally Other within the self. This is a radical departure from the sharp cleavage between the subjective and the objective world one finds themselves in. There is an inner reality which is as surely objective as any outer one. Don't go outside yourself, return into yourself. The dwelling place of truth lies in the inner man. And if you discover your own nature subject to change, then go beyond that nature; it is the reasoning soul which you go beyond. Press on, therefore, toward the Source from which the light of reason itself is kindled.

The gift of this experience has given me access to more of my Self. I have emerged from it with an enlarged capacity for love, along with an enriched zest and enthusiasm for life. I hold a deepened sense of knowing that we are part of the Great Universe and can never be separated or alienated from it. Our ability to see and function in reality can be enhanced as we acknowledge and deal with the scars of our ancestry, along with those encountered in our daily walk in life. We can start to offer forgiveness to others to the degree that we are loving and forgiving of ourselves. By embracing and wrestling with life as it comes to us, we can move towards the self-actualized person we really are. And in that state of true authenticity, grace unbounding flows in and through our lives, making each of us a loving and powerful healing force in the world.

Mitakuye Oyasin.Wankan Tanka nici un.
(All my relations, may the Great Spirit
go with you and guide you).

Die ew'ge Freiheit ist zu Ende,
die Katharine ihnen bot.
Das Wandern, Wandern nimmt kein Ende!
Wohin? Das weiss allein nur Gott.

(Where will this journey take us?
For Katherina it is over.
This wondering, where will it end?
Only our loving God knows.)

A Guide to Your Own Intergenerational Healing Journey

Not a day goes by that I don't recall, with joy and gratitude, the wonderful healing experienced by our entire family as a result of Kristi's pregnancies. Our relationships have grown significantly. We watch our family with an increased awareness of the power that intergenerational assumptions, lifestyle choices, and expectations have to influence health and illness.

Kristi and I are now encountering increasing numbers of people who have heard of our experience. To our surprise, they are seeking assistance for the healing of their own family

members who are experiencing illness, depression, addictions, and other afflictions that mirror their own health challenges. It has made us very conscious of a phenomenon that is quite common in society today: Repeating patterns of intergenerational health.

These repeated requests for help have caused us to reflect deeply on our own experience with healing. In our conversations we frequently process "lessons learned" that can be applied to other aspects of our lives as well as to the lives of others. In that process we have identified certain practices that, had we been conscious of them, may have altered our experience significantly.

It is with profound respect for your own unique life that we offer a four-part process that may facilitate your own awareness of intergenerational patterns that may be present in your family. Such insight can profoundly shift assumptions and influence choices towards a more balanced and healthy life.

PHASE I

Scouting Out the Landscape

Traveling the journey of life requires direction, resources, and energy. It also requires health and resourcefulness to navigate the vagaries of the world you inhabit. Our early ancestors traveled from Switzerland to Russia with a "possibility sack." In that sack were basics that would be utilized when they set up camp each night. It included string, spices, and tools for making a fire and cooking a meal. When they set up camp they would look around for "possible" food, water, and wood

sources to make the fire. They were creative and flexible in utilizing what was before them to meet their basic needs. They did not look for one specific item and shut down if it was absent. Rather, they scouted out the landscape and adapted to what was before them, becoming one with the land. How much more freedom would we feel if we would approach the modern world with a sense of "possibility" for our health and well-being rather than absolute expectation or the sense that there is only one right way?

Explore Your Ancestry

Exploring your ancestry is the starting point for your healing journey. Knowing where you come from forms the context that provides meaning for your own life experiences. It is the reference point, the landscape, the nest from which you emerged to enter the world. It is where many of the foundational assumptions that guide your expectations and choices originate, for these are the rules for acceptance and survival. Some salient questions to ponder:

- *Who is in the composition of your clan?*
- *Where were they from?*
- *What was their migratory pattern? (It is interesting to note how they got to the place where you were born.)*
- *Why did they move?*
- *What were their occupations? How did they establish themselves in the land they now inhabit?*
- *Or, did they stay in one place? What made them choose to stay?*
- *Who were the heroes and characters in the family?*
- *What makes them stand out? (Sometimes it is the black*

sheep, trying to break out of dysfunctional patterns, who becomes labeled by the rest who fear what such a change in consciousness could mean for the whole group).

- *What were the nicknames of key players in your family?*
- *What did the names mean and how were they acquired?*
- *What kind of celebrations and rituals were a vital part of your extended family that were also a part of their ancestral culture?*
- *Or...if you were adopted, what is the essence of that story? (There are no accidents in life. Wanigi Waci's worldview holds that "family" is a matter of spirit and vibrational frequency, not a matter of blood relation. For his People, family is a sacred commitment made by a group of spirits before birth. It is simply a matter of "showing up" at the appropriate time on our life journey to share in the unfolding story that informs and shapes our soul.)*
- *What are the transition points in your journey and what patterns are embedded within them?*
- *What people/patterns do you most resonate with?*
- *What things are most difficult for you? Often it is in that space that the true "growth of Soul" material resides!*
- *Draw the family tree: Instead of simply mapping out names and faces, add unusual or striking attributes or life circumstance to the names of people who hold a special place (positive or negative) in the family tree.*
 - *Who makes up your family tree?*
 - *How did the folks navigate life? Note the patterns of movement, of occupation, of illness or disease,*

of relationship.

— *Who are you most like and unlike? Get a sense of the energy and dynamics of the whole clan, being alert to sense a quickening inside yourself every time you discover one that is present in your life today.*

This reflective process provides a good time to visit with folks still living who remember some of the characters in the fabric of your family-of-origin story. Interview people who knew them. Gather old photographs. Trace migratory patterns through ancestral treasures and shipping lists. Visit the towns or countries they lived in. *Feel* the essence of who and what they were, what of them remains within your family today. Identify what you feel deep inside is the potential for your future based on your own family antics and the patterns uncovered.

Discover YourSelf

Discovering yourSelf is the next place to look for clues. When we are born our tribe and its culture forms and informs us. At some point in life the responsibility for discovering our authentic self, stripped of the rules and forms imposed upon us, becomes the primary task. We are then free to maintain, expand or replace the rules that at one time were life-giving, but now may be hindering our own evolution towards actualization. To do this you may want to engage in the following exercise.

Draw a blueprint of the home you lived in when you were twelve years old. Put into the picture favorite details like a tree, swing set, garden, or pet that you loved. In the house you may wish to add a favorite spot, details of a room

that was especially significant to you; the chair your father sat in, your mother's place in the kitchen, a window from which you watched the world go by at night. When it is complete, in your mind's eye return to that place and try to recall the following:

- *Who were the authority figures in your life at that time (teacher, preacher, parents, etc.)?*
- *What were the messages you received about power, money, success, and illness?*
- *What were the expressed expectations for your gender regarding behavior, dress, and career?*
- *What were those expressed for your siblings of the opposite sex?*
- *What were the rules for being "good" and "bad" and what happened if those boundaries were violated?*
- *What were the rewards (or punishment) for thinking outside the box, asking questions, doing things different than the norm?*
- *What happened if you made a mistake?*
- *According to family tradition, what happens when you die?*

It might be interesting to write out the assumptions you hold about gender-related expectations, power, money, success and failure, why people suffer, what happens to bad people, and to good people, thoughts about life and death. You will be surprised by them, and sometimes delighted, if you can muster the courage for total honesty. Take your time with this exercise. Revisit it frequently. Talk to your siblings and close friends. Visit teachers from your childhood, neighbors, rela-

tives, and friends to clarify, verify and amplify your memories and understandings.

To understand your pattern of growth and development, the way you move from one change to another, you may wish to complete the following exercise:

Make a list of years, starting with the year you were born, through this current year. Map out maturational crises or benchmarks such as starting kindergarten, high school graduation, your first job, etc. (This would include all the changes that people make based on years of age and traditional life transitions.)

Next, map out the situational crises in your life—the unexpected events such as illness, death, divorce, loss of job, moving to another town, separation from a dear friend, etc. (This would include things that one has not planned, things that often come as a shock, disrupting the pattern of one's life.)

Look at the changing pattern of your life. Some people show movement infrequently with the change being deep and sweeping. Others find that there is frequent activity with much dynamic shifting. Pay close attention to the white space between moves. While movement is interesting, it is usually the result of something that has been building up to that moment. Therefore, the essence of your lifestyle pattern, choices, activities, and outcomes is born in the rich ferment of what you do to prepare yourself for transition. Some people find that they always go back to school, and then there is a change. Others find that there is an illness that heralds the shift, while still others find that there is no one thing that propels them forward.

Recognize Patterns

Recognizing patterns fosters understanding. Once you have come to recognize and appreciate the unique pattern that is you, lay it along side the one that emerged as you studied your family of origin and ponder the following:

- What basic assumptions guide your expectations for life?
- Where did you learn them?
- How do you maintain/amplify/transcend them?
- How are they manifested in your children?
- Recognize, honor, and acknowledge the power of your family of origin and how deeply it has formed and informed you for your own life journey towards wholeness.

PHASE II

Mapping Your Health Journey

Wanigi Waci says that we come into this world to experience "all of life"; the joy and sorrow, the birth and death, the gain and loss...it is why our Soul chooses to incarnate in the material world. Balance is the foundation for health. It means one is centered and grounded, while being able to touch both sides of paradox without valuing one over the other. From the experience of "all that is" we come to understand the essence of life and our connection to all things. It is from this shared understanding that we realize that we are one Universal Family.

When we are in balance we are in alignment with all of life and share in the flow of energy pulsing through the Universe. This can be envisioned as a horizontal stream of life force con-

necting all things into a harmonious whole. If we suffer from "Ego Disease" we see ourSelves as superior to everyone and everything else, and we move ourselves outside and above the Universal flow. Then we must reach down and rob energy from others; a sense of power struggle ensues. Or, if we suffer from "Wego Disease," a low sense of Self, we live below this stream of life, and constantly folks who will pull us up and back into the flow by expending their own energy. So health is simply the process of living in harmony with Self and all things. What is the "story" about health from your worldview?

To uncover the assumptions and expectations about health that guide the life choices that foster or diminish your physical, mental, emotional or spiritual health you may wish to complete the following exercise:

- *Recognize your health beliefs.*
- *What is the meaning of health (physically, mentally, emotionally, spiritually)?*
- *How do you achieve, maintain, and enhance it from a religious/spiritual, cultural, and personal point of view?*
- *What makes people become ill?*
- *Why is the meaning of suffering?*

Recognize your health patterns.

- *How do you take care of yourself to foster and maintain health (nutrition, exercise, stress management, etc.)?*
- *Where did you learn your health/lifestyle habits and patterns?*
- *What diseases are in your family "story" that you anticipate may be a challenge for you?*

A recent national study by the Robert Wood Johnson Foundation found that currently the United States spends 90% of health care resources on access to medical care. However, when they studied the cause of illness, startling results were uncovered. Only 10% of illness is a result of lack of access to medical care. Twenty percent is related to heredity, and another 20% reflects the environment in which we live (physical and emotional). And 50% of our health status is created through lifestyle choices.

In my family's German culture food was a primary vehicle for socialization. Many times the best conversation flowed around the family table during mealtime. It was considered impolite to turn down a food offering created by the cook, and Grandmother's serving size was "ample!" Several salads and desserts always accompanied meat and potatoes, drowning in gravy. And, we saved many children in Africa from starvation by cleaning our plates! Moving into the new millennium with low-fat diets and a decrease in sugar intake almost felt like rejection of family. And when we gather today we slip back into old customs. Only now there is awareness which takes some of the joy out of the overindulgence that was once so commonplace. Learning to see our lifestyle patterns and to transcend them can be a lifelong struggle.

PHASE III

Navigating an Illness

The medical literature is filled with warnings of diseases that are hereditary in nature. Most of us know if our family has a

history of diabetes, heart disease, or cancer. And, we survey our own bodies repeatedly, looking for signs of family diseases showing up in us.

Wanigi Waci says that health is our birthright. We are already well. What we consciously and unconsciously focus on, what we hold to be "our truth," will manifest in our bodies and our lives. One generation's experience with a specific illness is held genetically and the potential for it is passed on to the next. But you may note that one family member may suffer from it while another will not. It is often a matter of consciousness that influences the inevitability of the pattern's repetition in the next generation.

It is important to note that it is not only the expectation of the person, but equally powerfully, the expectation of other key family members, that will foster the emergence of health or disease. Recent scientific studies also show that the expectation of the healers is another primary factor in the healing process.

If there is a family history of a specific disease process you may wish to complete the following exercise:

- *Examine illness when it visits you.*
- *Discover the problem—accurate identification is critical to recovery. Do not settle for treatment of side effects. Work with a wise and trusted health care provider or healer to properly diagnose the core disorder.*
- *What are some of the issues/patterns in your own life that may have made you vulnerable to an illness event?*
- *What are some of the challenges, stressors, exposures, or assumptions that may have weakened your own system?*
- *Who, as identified by looking at the patterns in your*

family of origin, also had this disorder?
- *What roles did they play in the family?*
- *What were the stressors/supports in their lives?*
- *How did they deal with it?*
- *What did or did not work for them in treating the condition?*
- *What was their outcome with the illness event?*
- *How are past family experiences with this challenge consciously and unconsciously informing your expectations about this health challenge?*

A great lesson for us was the fact that Kristi's illness was diagnosed on two distinct levels: On a personal level (her own physical experience of pregnancy challenges) and on a genetic level (the collective experience of our ancestral family). Working with several healing paradigms gave us a broader view of the phenomenon. You may wish to do the same.

Re-Source Your Journey Towards Recovery

Source your illness voyage with several perspectives if you are so inclined. Many people today are seeking support through the blending of remedies. They combine Western medicine with homeopathy, energy medicine such as acupuncture, massage therapy, and multiple emotional/spiritual resources.
- *What healing and comfort measures were extended to you when you were ill as a child?*
- *How many of them do you reenact when you or another family member become ill today?*
- *What healthcare practitioner/healer do you have confidence in and/or a relationship established with?*

(Seeing the same healthcare providers over time gives them a historic perspective of you and your family that helps manage the subtleties of illness with a deeper understanding).

- *Who answers your questions with thoughtful respect, and more importantly, who believes in your ability to recover and transcend the illness challenge? (If your practitioner in any way tells you that you must "learn to live with it," do not accept that judgment. Rather than going back to that practitioner, find one who offers the possibility for multiple outcomes, including full recovery. Miracles happen every day—as evidenced by the powerful story of cyclist Lance Armstrong and others. They are called forth by the knowing that any illness has potential for recovery.*

- *What other types of healing remedies and modalities might you be interested in? Seek the advice of health practitioners who know the field well for appropriate referrals. There are exemplary healers in all domains, along with those not as skilled. You deserve to experience quality and competence in the service rendered.*

- *How are you adapting and incorporating new health behaviors into your life to transcend lifestyle choices that lead to or enhance illness?*

Wanigi Waci says that health and illness are both parts of the paradox of living, and death is inevitable. But many times in life our body moves through cycles of health and illness. Often our body gets healed. Health, however, remains an option.

PHASE IV

Creating Meaning in Your Life

We must understand our history or we are destined to repeat it. This requires us to reflect on the events of our life and ascribe meaning to them. Meaning is the way people interpret a life experience to deepen their perspective and grow. It is a process that allows us to understand the role of the event in the larger landscape of our lives. When we are immersed in a crisis event all energy is focused on survival. It takes time and healing, and restored balance, to free up the energy necessary to do this difficult, but essential, work.

Though it has been several years since Kristi's illness, we continue to mine new nuggets of understanding each time our memory reflects back to those difficult moments of crisis. As we sort through the things we learned, three specific responses to the event appeared most helpful.

Surrender to the Moment
Initially we went through a period of disbelief, and then impatience to have the ordeal ended. As days moved into weeks, stretching into months, we kept struggling against what was occurring, and much energy was expended in that way.

One day, after a particularly frustrating visit to the hospital/ clinic and the words "no change" were once again pronounced, we made a subtle but profound shift. On the way home we looked at each other and said, "So if this is going to be the rest of our lives, what do we have to do to live with it?" In that moment we surrendered to what seemed to be the timeless/

endless reality of our current state.

Kristi started to work with her pain, not against it. I started to ration my time and energy between Kristi/work/mother/family in a conscious way. We both found ourselves trying to create a rhythm within the uncertainty of our days. Slowly we made peace with the fact that this was *here* and *now*. We quit looking back or ahead, just showing up to the day; living and being in the moment. At first this change in attitude took the edge off things, and then, slowly, we found we had more capacity to manage and cope. Not for one second did we quit planning for full recovery, but we took a kindlier attitude towards the current situation.

Wanigi Waci says we must make friends with the things that trouble us most. When we embrace them rather than reject them, they become a part of us and the lessons alter our consciousness. Together, Kristi and I started to live again, not suspended in the space between past and future, but in the moment. We started to notice moments of tenderness and insight, valor and cowardice, and we came to know ourSelves and each other in a deeper way. The process softened our heretofore-unquestioned expectations about life, and slowly gratitude began to creep in the space previously occupied exclusively by struggle and resentment.

Feel the Emotions

Wanigi Waci has established the Good Road, a program based on Native traditions that restore health. It is subtitled, "Healing Through Feeling." In the annual Good Road gathering, hundreds of "Wounded Warriors" gather for a time to share their stories, struggles and victories on the road to wholeness. A

healing village offers the participants experiences in many non-traditional healing modalities such as Reiki, iridology, and homeopathy. Native ceremonies such as The Wiping of Tears and Inipi are offered to all who have come together. It is a wonderful celebration of the diversity of humankind and the many healers who support their health journey.

We had attended these gatherings in the past, and were very clear that the only way to foster recovery was to embrace the emotions and let them "speak" to us. Owning and mining the most galvanized emotions was the most difficult part of the entire experience for us. It literally forced us to look at things we had experienced across our shared life journey. We both uncovered things between us that had been hurtful; a lack of "being there" at some critical time, moments missed because of busyness or inattention, comments made that were misinterpreted. Many tears were shed in those moments of candor, and, more importantly, forgiveness was extended both ways.

In *Molecules of Emotion* by Candice Pert, she cites current research supporting the understanding that emotions create bodily responses at the cellular level that move us towards safety or towards bliss. If we acknowledge the emotion, it is "experienced" and released. However, if we disavow the emotion or "stuff it," it stays buried in the cell, causing an imbalance in energy that ultimately leads to illness.

When we have an emotional event of magnitude, it is a challenge to transmute it. Whatever remains at the cellular level will resonate with each similar event over time. Therefore, sometimes a seemingly small issue can evoke a profound response. We may ask, "Where did *that* come from?" Embracing your feelings calls you to reflect on a strong reac-

tion of any kind and ask, "Where have I experienced this feeling before? When was the first time I can remember feeling it?" That process guides us into past moments that created assumptions, reactions, and expectations that become part of our pattern of behavior. While some of them are extremely helpful, others may have outlived their usefulness. Replacing them with more helpful, conscious reactions fosters healing at the deepest level of being. Reaching out to others involved in the event to express sorrow or offer forgiveness completes the circle of wholeness.

Honor Your Own Wisdom

One of the greatest challenges we face in Western society is the confidence in our own "knowing." There are experts on every conceivable topic that are only too happy to tell us what to do. And, unfortunately, we have been socialized to seek others wisdom to guide our own process.

A turning point in Kristi's illness was the night of unbearable pain. Wanigi Waci had told Kristi that day that she would have to decide what was helpful to her and what was not; no one else could do that for her. When she fell into shock, I had wanted to take her to the Emergency Room and she violently said, "No! I will die there!" and she started to move with her pain as she paced the room. From that moment forward Kristi started to manage her own illness event.

As a nurse/mother I would offer suggestions, many of which she rejected. I would take her to the clinic and she would tell me to come back and pick her up. Suddenly, she had taken her recovery into her own hands, and I was delighted to see that shift in attitude. I quickly learned to ask, "Kristi, what

would be most helpful now?" As an outside observer we so quickly jump into a situation with "solutions" to others dilemmas. Peter Block observed in *Stewardship: Putting Service Ahead of Self-Interest* that it is the misuse of our power to take responsibility for solving problems that belong to others. As Kristi claimed the wisdom of her own knowing, the recovery moved swiftly towards completion. And, today I notice how she gives her children the opportunity to make choices and decisions for themselves.

Today is a good day! We move through life a little lighter, a little freer, and a whole lot more aware.

New insights and capacities gained have enriched every aspect of our lives, and we wish the same for you.

Compassion—Whenever we go somewhere and see someone with chronic illness of any kind, we look at each other with a "knowing glance," thinking how that could have been the outcome of this situation for our family. It makes us feel an empathetic at-oneness with the other person.

However, Matthew Fox, in *A Spirituality Named Compassion*, says that empathy is simply not enough. He challenges us to be compassionate; being filled with such passion about the issue that we are moved to do something about it. Compassion is a call to social action!

We have worked with Wanigi Waci to acquire a grant that will bring together Native healers, Western physicians, alternative therapists, and a technology company to create an integrated care model for reservation-based Native Americans that will track their health experience among the various healers offering support and treatment for diabetes. We can be present

in this event because we are "living proof" of the power of this collaborative model of healing. What experiences have you had that have given you a unique insight and understanding that can be creatively leveraged to give back to society a lesson you have learned?

Gratitude—True gratitude moves us from thanks-giving to a life of thanks-living. Each day has become such a joy! Prior to the illness we often were looking forward to what would happen next. We also overlooked the beauty and gifts nested in the simple things of life, thinking profound moments and grand material things were the most important.

As a result of this event, our heroes are no longer the "rich and famous" but, rather, the poor and underserved, many of whom don't see themselves in that light. Have you spent time with folks who have little and see it as abundance? They delight in the beauty of a sunrise, they share the little they have because they know someone else that generous is living next to them. They live in harmony with their own rhythms, not artificially marching to someone else's definition of what is socially acceptable or politically correct.

Once I was visiting with a spiritual counselor who was very successful in her business. She was telling me of some of the wonderful experiences she had, and how she served her clients. I asked her, "What do the people do that don't have the money to access your wonderful insights?" She smiled and quickly said, "Oh, God talks to them directly!"

Self/Other Actualization—This event has stripped away the pretense and the veneer that had coated our beliefs, dictated our choices, and shaped our behaviors. When you are down to gasping for air, suddenly the breath of life is the sacred

thing. It is priceless, and while free, it cannot be bought when threatening illness is present.

As we come to know ourselves, we suddenly see the collective Self. And, in that space, all the petty differences, the minor altercations, the myriad set of man-made rules become irrelevant. As we experience the freedom, the joy, the beauty of coming home to ourSelves we can offer that same right to others. While still making judgments about issues in our own lives, we quit being judge over others. Scarcity is replaced with abundance, judgment is replaced with compassion, and fear is replaced with love.

And so, here is a map of the path we have taken. Yours will look different because you are unique in all of the world. Yours will hold many similarities because we are all One in this world. As each of us does this important, and sometimes difficult, task of intergenerational healing, balance will increasingly be restored in our lives, individually and collectively. Generation after generation, the circle of life goes on, and, when we work on transcending old patterns, it moves in an upward spiraling fashion. Here's to your health!

> The rock of memory
> Holds the scissors of pain
> A story written
> On paper black words turn to
> A white crane who flies away.
> —Lyn Coffin

Bibliography

I have two kinds of book recommendations: The first list is the way our culture addresses some of the issues/concepts in the book; the second is the Lakota way of seeing.

Western Viewpoint

Peter Block, *Stewardship: Choosing Service over Self Interest* (San Francisco: Berrett-Koehler Publishing, Inc., 1996)

Matthew Fox, *A Spirituality Named Compassion*. (San Francisco: Harper, San Francisco, 1990)

Robert H. Hopcke, *There Are No Accidents: Synchronicity and the Stories of Our Lives* (East Rutherford, NJ: Penguin Putnam, 1997)

Candace B. Pert and Deepak Chopra, *Molecules of Emotion: Why You Feel the Way You Feel* (New York: Scribner, 1997)

Lakota Sioux Point of View

Sun Bear and Wabun Wind, Black Dawn, *Bright Day: Indian Prophecies for the Millennium that Reveal the Fate of the Earth* (1992) (New York: Simon & Schuster, 1992)

Severt Young Bear and R.D. Theisz, *Standing in the Light: A Lakota Way of Seeing* (Lincoln, NE: Bison Books, 1994)

Archie Fire Lame Deer, The Life and Teaching of a Lakota Medicine Man. (Rochester, VT: Inner Traditions International, 1993)

Brooke Medicine Eagle, *Buffalo Woman Comes Singing: The Spirit Song of Rainbow Medicine Woman* (New York: Ballantine Books, 1991)

Wallace Black Elk, *Black Elk: The Sacred Ways of a Lakotan* (San Francisco: Harper San Francisco, 1991)

Edward Hays, *Sundancer: A Mystical Fantasy* (Leavenworth, KS: Forest of Peace Books, 1982)

Joseph M. Marshall III, *The Lakota Way* (East Rutherford, NJ: Penguin Putnam, 2001)

South Dakota Federal Writers' Project, "Legends of the Mighty Sioux" (Vermillion, SD: University of South Dakota Press, 1988)

John Steptoe, *The Story of Jumping Mouse* (New York: Morrow, William & Co., 1989)

Mark St. Pierre, Tilda Longsoldier, *Walking in a Sacred Manner: Healers, Dreamers and Pipe Carriers—Medicine Women of the Plains Indians* (New York: Simon & Schuster, 1995)

Native American Politics

Doyle Arbogast, *Wounded Warriors: A Time for Healing* (Omaha, NE: Little Turtle Publishing, 1995)

Fergus M. Bordewich, *Killing the White Man's Indian: Reinventing Native Americans at the End of the Twentieth Century* (New York: Bantam Dell Doubleday Publishing, 1996)

Vine Deloria, Jr., *Red Earth, White Lies: Native Americans and the Myth of Scientific Fact* (Golden, CO: Fulcrum Publishing, 1997)

Russel Means and Marvin J. Wolf, *Where White Men Fear to Tread: The Autobiography of Russell Means* (New York: Griffin/St. Martins, 1995)

PUBLISHER'S NOTE

We at Cresport Press are donating 10% of the net profits from *Mother, Heal My Self* to:

MAKOCE: Whole Earth Health
5209 East Valley Oaks Place
Sioux Falls, SD 57110

Makoce is a 501-C3 Not for Profit Organization committed to fostering total health and well-being of community. Its primary goal is to help build the capacity of individuals, reservation/ community, and institutions to enhance the quality of life for all citizens in the area.

AUTHOR'S NOTE

We hope this story of our family's and our personal journey has invited you to reflect on your own intergenerational journey of health and healing. If you'd like more information on intergenerational healing and the opportunity to join communities of others exploring it, you may reach us at:

JoEllen Koerner & Kristi Welch
2522 West 41st Street #248
Sioux Falls, SD 57105-6120
info@interhealing.com

Our Mission

We at Crestport Press believe that the best way our books can affect change is for our authors to state their positions boldly, present their beliefs unvarnished to the world, and then let the power of the written word affect change from the outside in. Our books express our authors' deepest passions and their commitment to their values and beliefs.

What You Can Do

If this book has positively impacted your life, you can help the author affect change by letting others know of her book's existence. Think about others of your acquaintance who are at a point in life where reading this book would have great meaning. Talk to them, phone them, or email them. Let them know that this author has created a work that could expand their lives.

To Order Crestport Press Books:

Crestport Press
5021 Gregory Court
Santa Rosa, CA 95409
800/247-6553
831/603-4193 (fax)
www.crestport.com
info@crestport.com